HAUNTED MARIETTA

HAUNTED MARIETTA

RHETTA AKAMATSU

Published by Haunted America
A Division of The History Press
Charleston, SC 29403
www.historypress.net

Copyright © 2009 by Rhetta Akamatsu
All rights reserved

First published 2009

Manufactured in the United States

ISBN 978.1.59629.737.1

Library of Congress Cataloging-in-Publication Data

Akamatsu, Rhetta.
Haunted Marietta / Rhetta Akamatsu.
p. cm.
Includes bibliographical references.
ISBN 978-1-59629-737-1 (alk. paper)
1. Ghosts--Georgia--Marietta. I. Title.

BF1472.U6A38 2009
133.109758'245--dc22
2009030602

Notice: The information in this book is true and complete to the best of our knowledge. It is offered without guarantee on the part of the author or The History Press. The author and The History Press disclaim all liability in connection with the use of this book.

All rights reserved. No part of this book may be reproduced or transmitted in any form whatsoever without prior written permission from the publisher except in the case of brief quotations embodied in critical articles and reviews.

CONTENTS

Acknowledgements	7
Introduction	9
A Few Words about Language and Paranormal Investigation	13
A Little Background History of Marietta	19
About the Nature of Ghosts	31
A Historical Marietta Ghost Story	35
Shades of the Civil War	37
Cemetery Shades	59
Haunted Bridges	81
Shades of the Square	85
Haunted Houses and Buildings	97
A Contemporary Marietta Ghost Story	115
Conclusion	119
Appendix. Visit Some of these Places and Learn More about Marietta	121
Bibliography	123
About the Author	125

ACKNOWLEDGEMENTS

I would like to thank Allison Stauble for getting me started on this project at The History Press, and Laura All and John Wilkinson for helping me continue it, as well as the rest of the staff at The History Press for their assistance in this project.

I would also like to thank those people who shared their stories and material with me and allowed me to share them with you, including my daughter, Rose Gillespie; Eddie Hunter of the blog "Chicken Fat"; Andy Roberts of Atlanta Ghost Hunters; and Patrick Burns of Ghost Hounds, among others who wished to remain anonymous. You know who you are.

Rose also accompanied me and provided support on photo-taking trips, and she and my son, Jeremy Gillespie, provided tips and introductions to people who offered personal stories and information.

In addition to taking great photos for me, I owe a huge thanks to my husband for his patience and for allowing me to talk to him endlessly about Marietta ghosts and Marietta history and for driving me all over creation to take pictures and do research.

My friend Crystal Pinson provided a number of photos for this book and great companionship as we explored the Devil's Turnaround and St. James Episcopal Cemeteries. I really appreciate her expertise, her friendship and her enthusiasm.

Acknowledgements

Patrick Burns not only shared stories but has also taught me, through the Ghost Hounds, much of what I know about paranormal investigation. I also owe a debt of gratitude to Doug Kelley of ParaNexus for his excellent course in paranormal investigation, which allowed me to become a certified paranormal investigator.

Joni Goodin, of the excellent Ghosts of Marietta ghost tour, not otherwise associated with this book, has generously shared information about several locations on the square with me.

In addition, I want to thank my fellow Ghost Hounds for their inspiration and my colleague and the publisher of the *Journal of Anomalous Sciences* Jari Mikolla for his friendship and support.

Other people who have assisted in the development of this book include Dan Cox of the Marietta Museum of History and Charles Switzer of the Holly Springs Memorial Association, as well as various members of the Cobb County Preservation Society and the Cobb Historical and Landmark Society.

If you helped me with this book in any way and I didn't mention you here, please believe me when I say that it was not intentional.

In closing, I want to thank you, the reader, for allowing me to share my town, its history and its ghosts with you. I hope you have as much fun reading this book as I have had writing it.

INTRODUCTION

I moved from South Carolina to Marietta, Georgia, with my then husband and two children in 1993. For work-related reasons, we needed to be close to Atlanta, but I was a country girl, and I did not relish adjusting to a big city. I fell in love with Marietta right away, with its small-town charm and convenient location just fifteen miles from Atlanta and all of its many cultural, shopping and entertainment enticements. I love history, and to step into Marietta Square, the heart of downtown, is to immediately feel how close the past still lingers around here. Marietta was first established in 1834, and many of Marietta's buildings remain largely unchanged since the early days of the 1900s, while a few still linger from Civil War days, like the historical and haunted Kennesaw House, the Root House and the railroad depot where the Welcome Center is located.

I now live in a neighborhood very near Kennesaw National Battlefield and within walking distance of the historical Kolb Farm location, where the original farmhouse still stands, restored to its former appearance. On the land where my neighborhood is located, soldiers in blue and gray fought a fierce and decisive battle nearly 150 years ago, as the Confederate army desperately and futilely tried to keep Sherman's troops from claiming the railroad and reaching Atlanta. When I am out walking around, I can often feel them just out of my line of vision, flitting through the remaining trees that surround my neighborhood.

INTRODUCTION

Indeed, there are very few areas in Marietta that did not see fighting during the War Between the States, and the entire town was occupied by the Union forces for months after the Battle of Kennesaw Mountain. Those memories are still very close to the surface here.

Today, Marietta is a growing, vibrant city, with new town homes and condominiums springing up that offer great urban living but do not change the friendly, small-town vibe of the square, with its great restaurants, pubs, antique shops and family-friendly Glover Park, where festivals and concerts occur frequently in the spring, summer and fall. When the weather is fair, people stroll in the evenings or sit at street-side tables and listen to the music from Hemingway's or Cool Beans Coffee Shop or from whatever is going on in the park. The feeling is laid-back and friendly, both thoroughly modern and nostalgic at the same time.

And there is a hidden side to Marietta, created from all of the history and drama of the past.

For all of my life, I have had an interest in the supernatural. My parents were staunch Southern Baptists and officially did not believe in ghosts. Paradoxically, as happens throughout the South, we were living with ghostly activity every day, and whenever something unexplainable happened in our house, my parents matter-of-factly explained that it was "just the ghost." Having the child's ability to hold two opposing thoughts in my head with no problem, I accepted this.

And, in fact, southerners accept this kind of situation as routine all the time. Just because you don't believe in ghosts doesn't mean they aren't there, seems to be the reasoning. So I grew up with the sounds of a phantom car that went around the house every day at the same time, even though we were over a mile from the nearest paved road, and I took a mischievous ghost with me when I went off to college. It used to hide my books under my bed while I was in the shower or move all of my record albums out in the hall through a closed door and perform other harmless but annoying antics. And I was never afraid of any of this, nor did I find it particularly strange. My daughter, as we shall see later in this book, has inherited both the ghosts and my attitude toward them.

Later, I became interested in such television programs as *In Search Of* and *Haunted History* and avidly read whatever ghost books came to hand, including the excellent *Charleston Ghosts*, which was

written by a woman I have been told is a distant relative of mine, Margaret Rhett.

But it was not until I heard Patrick Burns and several other Ghost Hounds members discussing an investigation they did at the Kennesaw House here in Marietta at DragonCon, an enormous science fiction convention that takes place in Atlanta and also includes a large paranormal division, that I got interested in Marietta's paranormal history and in paranormal investigation in general. I believe that this was about 2001 or 2002. Of course, now, with the success of such shows as *Ghost Hunters* and *Paranormal State*, many people are interested in paranormal investigation, but it was an almost unheard-of field a few years ago, and the subject was not so popular and well publicized at the time.

After I saw the Ghost Hounds presentation on the Kennesaw House, which provided some fascinating evidence that I will also discuss later in the book, I wanted to know more. But it was not until 2006 that my husband and I actually joined Ghost Hounds and became involved in paranormal investigation ourselves. (My husband is an interested skeptic who has not decided what he believes, except that there are more things in heaven and earth, as Shakespeare observed, than we currently understand.)

Shortly thereafter, I began writing about the paranormal, and naturally, one of my very first articles was about the Kennesaw House. Since then, I have written two guidebooks to paranormal travel, *Ghost to Coast* and *Ghost to Coast Tours and Haunted Places*; developed two paranormal websites, ghosttocoast.us and the Paranormal Directory at boomja.com; become the editor of a journal that features every kind of anomalous science; and written many articles about Marietta, both its paranormal and its non-paranormal history.

All of that brings me to this book, which is devoted to this city I love and its rich history of paranormal events. Through the experience of writing this book, I have learned so much about the colorful and dramatic past of this, my adopted, city, and I find myself constantly reminded of ghostly inhabitants and the events that spawned them everywhere I go. Come along with me to visit some of Marietta's most haunted locations and to capture the essence of this area of Georgia. I believe you are going to enjoy the trip.

A FEW WORDS ABOUT LANGUAGE AND PARANORMAL INVESTIGATION

Like any other field, the paranormal has its own terms to describe various types of experiences or apparitions. The most important ones that I have used in this book may need a little explanation. In addition, it may be appropriate to explain a little about paranormal investigation in general, as it plays its part in this book.

There are generally considered to be three types of ghosts: residual, intelligent and demonic. You will not find demonic spirits in this book because I personally do not believe in demons (although I do believe in angry and possibly malevolent spirits: if a person was bad in life, he may well be bad, though much less powerful, in death). Indeed, I have not encountered any stories in Marietta that would be considered demonic, even by true believers.

"Residual" ghosts are those that do not represent a spirit or any sort of lingering intelligence. They are merely "movies," or a sort of holographic image that is stamped on the air by great emotion or some traumatic happening. These are the ghosts that are always seen in the same place, doing the same thing, time after time. They are usually the ones that walk through walls, seem to float in the air or go through doorways that are no longer there. Because they are merely reenactments, changes in the location do not affect them. When visitors to battlefields see entire reenactments of scenes, these are residual hauntings. Also, when people see manifestations from the knees up, or only see legs and not whole bodies, these are generally

residual. If the floor is higher than it used to be or the ground is not at the same height as it was, the scene will still replay, unchanged, but we will no longer see all of it. In some haunted places, such as the Theatre in the Square in Marietta, whole scenes from the past, including the former look of the location, materialize.

Paranormal investigators are people with a serious interest in trying to discover the truth behind ghost sightings and paranormal activity by capturing evidence on film or tape or by using other instruments to document such data as electromagnetic fields (EMF), which some people believe may indicate ghost activity if there seems to be no scientific reason for higher than normal EMF readings, and temperature drops and spikes. "Cold spots," in particular, are sometimes believed to indicate spirit activity. There is a theory that spirits can use electromagnetic energy, energy from batteries and energy from the atmosphere to manifest, and that is the reason we take EMF readings and temperature readings and look for cold spots. It also explains why brand-new batteries are prone to drain in some places. The so-called Witch's Graveyard in Marietta is a good example of a place that has both unexplained temperature drops and a tendency to drain batteries.

Some people make a distinction between "paranormal investigators" and "ghost hunters" in one of two ways. Some claim that ghost hunters are less interested in explaining paranormal phenomena than they are in just experiencing it. Others say that ghost hunters tend to investigate places that are already known to be haunted, while paranormal investigators tend to investigate less well-known places, where people are experiencing activity or sightings and have asked for help. Most people in the field probably do a little of both, and the terms are often used interchangeably.

There is a theory that some weather conditions may be more conducive to observing ghostly activity, such as during and immediately after a storm, probably because of the electricity in the air. Solar flares and full moons also may affect paranormal activity, due to the effect on gravitational pull and geomagnetic fields.

Investigators have noticed that certain times of the year seem to be more active than others in Marietta, and most believe this has to do with dramatic events in the town's history, particularly the Civil War. May, June, September and the winter months seem to be very, very active times for ghost sightings and paranormal activity in Marietta.

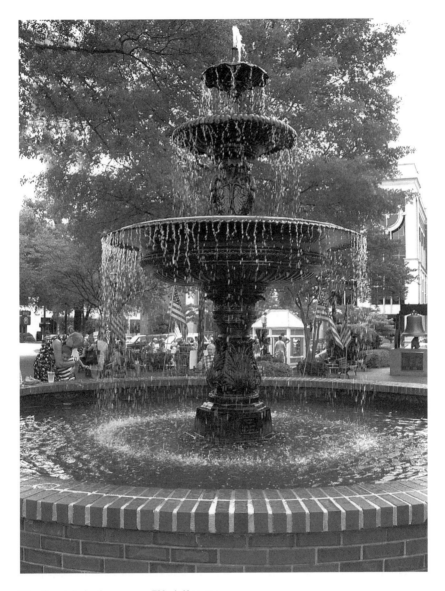

The fountain in the square. *Takesi Akamatsu.*

"Sensitives" are people who seem to have abilities to tune into psychic energies. Some sensitives are mediums and can seemingly speak to spirits, and some can sense when spirits are present or read the past of a place without prior knowledge of it. Others, like me, are very sensitive to emotions, both past and present, and can sometimes

A view of Marietta Square in the 1890s. *Courtesy of the Marietta Museum of History.*

pick up feelings connected to people and places. Good investigators do not accept the experiences of sensitives as evidence because these experiences often cannot be documented, but sensitives can provide helpful clues about good places to take pictures or do EVP sessions, and they can often provide names and background information that can be researched later.

When an investigator or observer speaks of an entity as "intelligent," that means that the spirit seems to be capable of corresponding or interacting in some way with the living persons involved or with the environment. EVPs (electronic voice phenomenon) are considered by many people, including myself, to be some of the most convincing evidence, especially when the message seems to be a direct answer to a question. Another example of what may be a sign of an intelligent entity is poltergeist activity, where things are moved around or mechanical items like clocks or radios are affected, such as the activity we will discuss at the 1848 House.

In this book, I may mention ghosts as being "grounded," "in visitation" or "visiting." "Grounded" means that they seem tied to a place, unable for some reason to move on, while "in visitation" means that they can and have moved on, but they occasionally come back to visit, perhaps to check on a place they have loved or to try to tend to some unfinished business. Most of the ghosts that are spotted in windows around Marietta may be "in visitation."

"Active" means that a place seems to have a lot of paranormal activity of some sort going on, such as ghost sightings, EVPs, unexplained sounds, doors opening on their own, etc. Often, investigators are

willing to call a place "active" even if they are not yet ready to say that it is haunted. It means that something is definitely going on, but no one is sure just what.

EVPs are voices that are caught on tape that were not heard at the time and do not belong to anyone living who was present. Sometimes they are whispers; sometimes cries, moans or very clearly stated words are captured and not heard until the tape is reviewed. EVPs are most convincing when they seem to reflect something about the location or the situation at hand, such as the EVP from the Kennesaw House that mentions General Sherman.

A LITTLE BACKGROUND HISTORY OF MARIETTA

In 1824, four houses were all that existed on the site of what was to become Marietta, the homes of intrepid settlers who had claimed land near the Native American town of Kennesaw. That same year, the first ferry across the Chattahoochee was established at Shallow Ford for the use of wagon trains heading from Georgia's coast or from North Carolina to Alabama. A man or horse could use the ferry for five cents, while a fully loaded wagon, horse and driver cost one dollar. Before long, James Powers and Johnson Garwood started two more ferries, Powers Ferry and Johnson's Ferry. Shallowford, Powers Ferry and Johnson's Ferry are well-known names today in Marietta because of the roads that memorialize them. The ability to get across the river made the area a much more attractive place to settle.

Many more settlers were drawn to the site by the Second Land Lottery in 1832. At that time, the Cherokees were being removed from Georgia by force because of the discovery of gold and the subsequent Georgia Gold Rush. Marietta did not participate in the gold rush to any great extent, but the land was available for lottery due to the removal of the Cherokees on the infamous Trail of Tears. The cruel fate of so many of the Cherokees who were forced to leave their land and their sacred places is the probable cause of many of the spectral drums and war whoops, and the

occasional sightings of ghostly Cherokee braves in full Native American dress, around the area.

In 1833, the first Marietta plat, with the square and the courthouse in traditional southern style, was laid. The state legislature recognized the town in 1834, and in 1837, the *Georgia Gazetteer* announced the name of the city: Marietta, in Cobb County, named for the wife of Supreme Court judge and U.S. senator Thomas Willis Cobb, for whom the county had been named. Another, more colorful theory, however, holds that the city was named for two local young ladies who so charmed the Marietta gentlemen that they combined their names, Mary and Etta, to form the name of the town. The first buildings were made of log, and the streets were dirt when it was dry and mud when it was wet. Among the earliest establishments were two taverns and four churches.

Before long, Marietta was selected as the location for the Western and Atlanta Railroad. Construction of the railroad began in 1838, but political wrangling slowed the progress, and it was not until 1850 that the railroad became operational.

With the railroad came prosperity. Stagecoaches ferried rail passengers from remote areas to the railroad, stopping at the stagecoach depot owned by Dix Fletcher and his wife. When it burned down in the mid-1850s, the Fletchers purchased a cotton warehouse from John Glover, which became the Fletcher House and then the Kennesaw House.

Now that Marietta was a settled town with a purpose, it was time to incorporate. This was done in 1852. John Glover, a businessman with political ambitions who had arrived in town in 1848, was elected the first mayor. Glover was the builder of Bushy Park, which would in time become the famously haunted 1848 House.

In 1840, Dr. Carey Cox promoted a "water cure," one of the most popular "medical" treatments in the 1800s, and established a spa, hotel and sanitarium in Marietta that attracted visitors from all around. People came from everywhere, but especially from the Lowcountry of South Carolina and the Georgia coast during the summertime, to escape the dangers of malaria, which was rampant and deadly there, and for relief from the oppressive heat of the coast.

This, with the establishment of the Georgia Military Institute in 1851, added to Marietta's prestige in the area. The institute began with 7 students. At the end of the first year, there were 28 students.

By 1853, there were six instructors and 180 cadets. The number of cadets remained between 150 and 200 every year until the outbreak of the Civil War.

The institute was built on 110 acres off Powder Springs Road and included eighteen buildings, among which were four dormitories, a main school building and Brumby Hall, the beautiful home of the first superintendent of the institute, Colonel Arnuldus V. Brumby. Here, before the war, cadets received not only military training but also instruction in engineering, science, mathematics, history, grammar and religion: the well-rounded education that every southern gentleman was expected to have.

During the war, the institute was used by Confederate and then Union troops through the battles in Marietta, during which time it remained open, although by 1864 all of the students had gone to war. It was burned by Sherman's troops in November 1864 and never reestablished. Only Brumby Hall survived, and it is said that it was spared because Colonel Brumby and General Sherman had been friends at West Point before the country was so cruelly divided. The house fared poorly after the war, until it was bought and restored in 1926, and the beautiful, extensive gardens that exist today were created. It was bought by the City of Marietta in 1996.

But back to the 1850s. Despite three disastrous fires that nearly destroyed the city in just a few years, Marietta was, by the time the Civil War arrived, a prosperous city with a booming tourist industry created by the railroad. It continued to grow and prosper until it was nearly destroyed by the storm of war.

In April 1862, Marietta took its place in Civil War history for the first time.

One night, a civilian, James Andrews, arrived at the Fletcher House hotel, which later became the Kennesaw House. The Fletcher House was conveniently located right next to the railroad tracks, and Dix Fletcher was known to have Union sympathies. Once he arrived, Andrews was joined by twenty-two other men, who became known to history as Andrews' Raiders. They had a daring plan to bring an early end to the War Between the States.

In *Stealing the General*, Russell S. Bonds reports a conversation between James Andrews and his men. "Now my lads," Andrews is reported to have said, "you have been chosen by your officers to perform a most important service, which, if successful, will change

the whole aspect of the war and aid materially in bringing an early peace to our distracted country."

What was this "most important service"?

They were going to steal a train. The plan was that they would then take the train to Chattanooga to meet up with the Union army, in the meantime doing as much damage to the tracks and the railroad equipment as they could manage along the way, disrupting and making the Western and Atlanta Railroad unusable. This, had it succeeded, would have been a tremendous blow to the Confederate army.

No one noticed anything out of the ordinary when Andrews and his men boarded the train, known as the General, in the early hours of April 12, 1862. But when the train stopped at Big Shanty (now known as Kennesaw) for the passengers to have breakfast, Andrews and his men made their move: they stole the engine and the fuel car and began the incident that would later be known to generations as the Great Locomotive Chase.

The conductor of the General and two other men chased after the raiders on foot, by handcar and on foot again, all the way to Adairsville, where they commandeered a train known as the Texas. The Texas was a southbound train, and now the Texas was chasing the General in reverse. The chase continued all the way to Ringgold, Georgia. The raiders were able to do some damage to the track, but not nearly as much as they had planned. In Ringgold, the General ran out of fuel. Andrews's men abandoned their prize and scattered but were soon captured. James Andrews and seven of his men were hanged. The other fourteen were sent to prison camps, where eight of them subsequently managed to escape. The other six were eventually exchanged and achieved their freedom.

And it all began in Marietta, Georgia.

After the war, the General was almost destroyed. In 1891, it was discovered in Vinings, Georgia, not far from Marietta and Kennesaw, on the scrap line and was destined to be turned into scrap metal by the Nashville, Chattanooga and St. Louis Railway. It was rescued, rebuilt and used for Civil War reunions and promotional purposes, finally ending up housed in a Chattanooga depot until 1962, when the Louisville and Nashville Railroad sent it for a centennial run. Today, you can see the General in its restored glory at the Southern Museum of Civil War and Locomotive History in Kennesaw.

General Sherman invaded Marietta in 1864 as part of the Atlanta Campaign, and fierce fighting ensued at Kolb's Farm and Kennesaw Mountain Battlefield, as well as many other places around the city and its neighboring area. After the Battle of Kennesaw Mountain, the town was occupied for four months and subject to martial law. There were hospital tents pitched in the square, and at times up to three thousand Union wounded were being treated there. Nearly every large house in the area was being pressed into use for Union headquarters or for hospitals, and most of the citizens had fled, although there are a few tales of brave women who stood in their doorways and defied the soldiers to take their homes, one of whom was pregnant at the time. They prevailed, and their homes were spared. These stories are the rare exceptions, however.

The crops, chickens, pigs, cows and horses were all raided for the use of the Union army. Even the vegetable gardens were picked clean. Most of the citizens were either forced from their homes and businesses or fled them, unable to live under such conditions. The houses were stripped of everything of value that could be carried, and many valuables that could not be carried were wantonly destroyed. Furniture was burned in fireplaces, and horses were stabled in parlors and hallways. At St. James Episcopal Church, the beautiful organ that the ladies of St. James bought in 1860, for which the funds were raised with ice cream socials and concerts, was thrown out into the street by the Union troops occupying the church. A church member managed to salvage it, and it was repaired and returned after the war. It is still in use today.

That fall, Union general Hugh Kilpatrick set the town on fire. This was the first strike in Sherman's infamous March to the Sea. More than one hundred houses burned. As a result, very few pre–Civil War houses remain in Marietta, although the Kennesaw House survived with only the loss of its top floor. The 1848 House, the Chaney-Newcomer House, the Root House, the main house at Kolb Farm, the Brumby House and several others also survived. Most of the downtown area was entirely destroyed. For ten years, the marble columns that had fronted the courthouse, all that remained of the building, stood as a grim reminder of the destruction; they were called "Sherman's Sentinels." The city was so broke that it was not until 1872 that the columns were pulled down and a new courthouse was constructed.

The Civil War left its legacy of ghosts and spirits here, as it did throughout the country. In Marietta, there is hardly an area that does not have its tales of spirits of men in blue and gray, still replaying their parts in that bloody and tragic conflict. In addition, the city suffered, by 1864 and for several years after the war, from a terrible food shortage. Crops, cattle and even the vegetable gardens had all been raided by both Confederate and Union soldiers, and those that managed to survive were burned. Great parts of the railroad were destroyed and had to be repaired. Most of the citizens had left the city during the occupation, and they returned to nothing but ruin. At one point, shortly after the war, the treasury for all of Cobb County contained only sixteen cents.

Robert McAlpin Goodman, founder of the *Marietta Journal*, reminisced in 1873 about the appearance of the town in 1866, when he started the newspaper:

> *Marietta was a heap of ashes and a charred mass of ruins…houses were desolate, kindred scattered, the people impoverished, and fields a waste, lined with the mounds and entrenchments of a bitter and fruitless struggle…our political sky was without one ray of hope, but black with impending evil.*

Is it any wonder that this blood-soaked, occupied, nearly destroyed area abounds with ghosts from this era? If angry ghosts watch from windows shaking their fists, sad figures wander through houses built atop battlegrounds or shadows in blue or gray flit from tree to tree, who can be surprised? Surely, it would be more amazing if this terrible conflict had not left its shades upon the present.

Nevertheless, after the war, like the rest of the South, Marietta rebuilt. And, in large part because of the railroad, before too long, it returned to prosperity. After 1868, Marietta also benefited from its proximity to the new capital, Atlanta. By 1870, new shade trees had been planted around the square, and houses were being rebuilt. Business resumed, and life began to take on some form of normality.

The years between 1880 and 1905 showed special growth and change in Marietta. In 1880, the city gained electric lights. In 1897, Marietta resident Alice McLellan Birney organized the National Congress of Mothers, which became the Parent

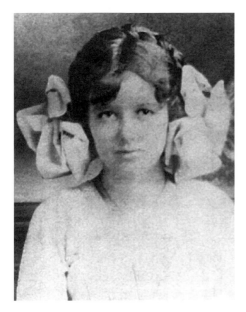

Mary Phagan near the time of her murder. *Library of Congress.*

Teacher Association (PTA). In 1898, telephones revolutionized communication in the city.

By 1900, there were forty-five hundred people in Marietta. In 1905, a trolley began providing transportation between Marietta and Atlanta. The twelve-mile run took about thirty minutes, which is ironically less time than it usually takes in today's traffic. It continued to run until 1947 and made it possible for more people to live in Marietta and work in Atlanta.

Like many cities, Marietta's history also contains a very dark spot that occurred almost fifty years after the war. Salem has its witch trials, Chicago has the gangland murders and Marietta has the case of Mary Phagan.

Mary Phagan was a thirteen-year-old girl who worked in the factory of the National Pencil Company in Atlanta in 1913. She had started working at a very young age to help support her widowed mother and five siblings who lived in Marietta, where Mary was born and spent her abbreviated childhood. By 1913, her mother had remarried, but Mary had gained a taste for independence, and she liked her work, despite the low wages, so she continued to work in the factory.

On April 26, 1913, Confederate Day, which was a very big deal in the South in that time period, Mary went to the pencil company

to pick up her check for the week (which amounted to less than two dollars for a week's work). She was excited and happy, looking forward to the festivities that evening. The factory supervisor, a Jewish man from the North named Leo Frank, gave her the check. He was the last person to officially admit to seeing Mary Phagan alive, even though other people later said that they saw her at the parade and the big block party afterward. They said this after both Mary and Leo Frank were dead.

Shortly after three o' clock in the morning on April 27, a watchman named Newt Lee discovered the badly beaten body of a young girl in the basement of the factory. She was so covered in filth that at first the police thought that she was a black girl, but when one officer pulled down a stocking, they found that she was white. Shortly thereafter, a co-worker identified the body as Mary Phagan. She had been bound, beaten, strangled and may have been raped, although the evidence for that was inconclusive. Either way, she was dead. There were signs that she had pulled herself along the basement floor at some point, and two handwritten notes she had allegedly written were found at the scene, in which she claimed that a "Negro" had murdered her.

Despite the notes, suspicion originally fell on Lee and on a janitor in the building, Jim Conley; in the end, Leo Frank became the prime suspect, despite any real evidence that he committed the crime. He was a Jew and he was from the North and that was enough.

Frank was thirty-eight years old, originally from Philadelphia and a married man. He was a lover of classical music and was thought well of in the Jewish community in Atlanta at that time. However, among the women and girls of the factory, he seems to have had a reputation as a bit of a "masher," often making insinuating comments and inappropriate remarks to them, although there is no evidence that he ever acted on any of his insinuations.

The trial began in July. The newspapers had a field day, and a circulation war erupted that led to reporting that had little regard for the difference between truth and hearsay and helped condemn Leo Frank. Despite the fact that Jim Conley had admitted to carrying the body to the basement, the black janitor claimed that Leo Frank helped him do so. He also said that Frank forced him to write the murder notes, and this testimony stood even though Conley had earlier claimed, under oath, to be unable to read or write. While the evidence against Conley was stronger than that against Frank,

the Atlanta newspaper opined that no black man was capable of a complicated scheme, and therefore he must not be guilty.

In the end, Frank was convicted on a wave of anger and anti-Semitism and sentenced to hang. Legal wrangling delayed the death, and in 1915, the then Georgia governor commuted the sentence to life in prison and had Frank transferred to the state prison in Milledgeville due to additional evidence that shed more doubt on Frank's actual guilt. But a mob of men, many of them powerful and influential Marietta citizens, broke into the prison, took Frank by force and returned with him to Marietta, where they hanged him near the corner of Frey's Gin and Roswell Road, across from where the Big Chicken stands today. Townsfolk proudly had their pictures taken next to the hanging body.

It should be remembered that in those days, lynchings were often social events. People would bring picnics and spread blankets on the ground and watch a lynching like they would a play. This practice occurred not only in the South but also everywhere in the country where lynchings occurred. It was common for postcards to be made up of infamous lynchings—there are postcards of the Frank lynching—so that people could send them to their friends who were so unfortunate as to have missed the event. Small bits of clothing were torn from the body and strands of rope were snipped to sell or keep as treasured souvenirs. Most people were completely convinced that justice had been done, and they rejoiced in the fact. Later, at the mortuary, such a crowd gathered demanding to see the body that the police were alarmed. They allowed the crowd in, and an orderly line of more than fifteen thousand people viewed the body.

Nearly seventy years later, in 1982, a former office boy named Alonzo Mann, who was in ill health and in danger of dying, came forward to admit that he saw Jim Conley carry Mary Phagan into the basement alone. Mann had been thirteen years old at the time of the crime. He said that Conley threatened his life if he ever told, and he never did. The Georgia Board of Pardens and Paroles subsequently pardoned Leo Frank posthumously. Recent speculation is that Conley intended to rob Mary of her pay but that he panicked, knocked her out and subsequently killed her when she fought back.

But the death of Mary Phagan was not only a tragedy for this little girl and Leo Frank. Shortly after the hanging, a group of men met

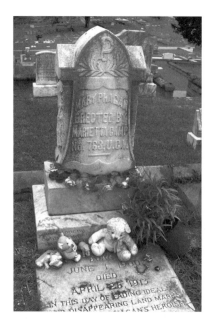

Mary Phagan's grave, where people still leave tributes today. *Takesi Akamatsu.*

at Stone Mountain and formed the first Georgia branch of the Ku Klux Klan. According to Frank's tombstone in New York, the trial of Leo Frank was so obviously motivated by anti-Semitism that the Anti-Defamation League was formed as a result to try to avoid this kind of injustice in the future. So untold misery and injustice and inestimable triumph for social justice arose from this one despicable deed and the unreasoning anger and racism that it inspired. Frank was the only Jew ever hanged on American soil.

Despite this violent history, little Mary Phagan seems to rest easy in her grave at Marietta City Cemetery, where visitors still leave trinkets and teddy bears in tribute. Her headstone's inscription speaks poignantly of the aching hearts and tears welling in eyes unaccustomed to crying that her murder caused throughout Georgia, at least as far as any written record attests. Leo Frank, as well, seems to have found no reason to linger around the place where he met such a sad end, and that is as it should be.

Other than this blot upon its history, Marietta, after the Civil War, became first a railroad center and then a center of commerce as well.

In the 1930s, Marietta enjoyed frequent visits from starlet and girlfriend of mobster Bugsy Seigel, Virginia Hill. She was born in Alabama but raised in Marietta, and she often came home to visit

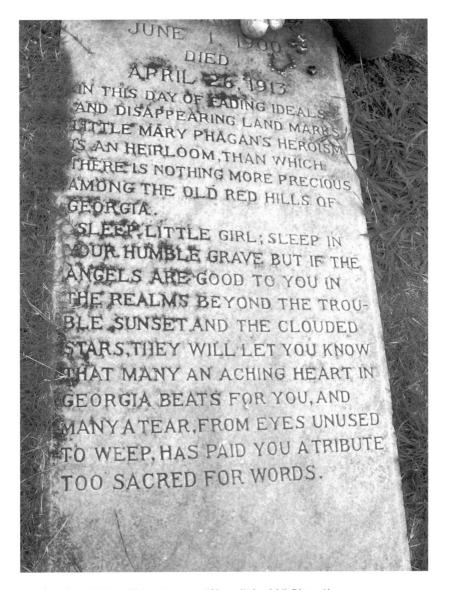

Another view of Mary Phagan's grave: "Sleep, little girl." *Rhetta Akamatsu.*

her mother. During the Depression years of the '30s, her visits were a great boon to the economy of the city, as she spent lavishly, paying cash from rolls of $100 bills for whatever she wanted, including, on one occasion, a Buick convertible for her brothers. She was smart, sassy and more than a match for her mob boyfriend. She was also

quite a character as she rode through the streets of Marietta on a horse she kept just for her visits to town.

During World War II, the city was once again a hub of military activity. The city's Rickenbacher Field became the location of the Bell Bomber Factory. Here, 669 B-29 bombers were built, tested and shipped to the troops. Over twenty-nine thousand people, many of them women, worked in the plant shortly before the end of the fighting. After the war was over, the facility was taken over by Lockheed-Martin in 1951. Actress Joanne Woodward, who is a native of Marietta, visited her brother at the plant when he worked there in the late 1950s. Lockheed-Martin is still a major employer in Cobb County.

The Army Military Airport was also created in Marietta in 1943 and was then transferred to the Air Force in 1948. In 1950, it was renamed Dobbins Air Force Base in honor of Captain Charles Dobbins, a flyer from Marietta who was shot down during the war. Dobbins Air Force Base is also still a major part of Marietta's industry today. At present, it handles air traffic control for Lockheed, the U.S. Air Force, the U.S. Marines and the U.S. Navy.

During the years from World War II to the present, Marietta has continued to grow and prosper while preserving its small-town atmosphere and sense of history. The drama at the square did not die with the war years, however. In 1963, while hundreds of people were gathered on the square for a Halloween celebration, a natural gas leak caused a massive explosion that annihilated Atherton's Drugstore, killed seven people and wounded twenty-three others. This explosion may have something to do with the occasional report of strange, disfigured apparitions on the square, which I have not treated in detail in this book due to the lack of any real corroboration for the stories. However, since most of the people were dressed for Halloween, this could explain the stories that sometimes pop up of ghosts with animal heads and human bodies.

While we take a look at the paranormal history of Marietta, we will look at more incidents that illuminate the fascinating history of this wonderful town.

ABOUT THE NATURE OF GHOSTS

Given the nature of this book, it seems appropriate to take a few moments to consider the nature of ghosts. Think back for a moment. You probably remember telling ghost stories around a campfire or at a sleepover late at night, or some other instance when you have shared stories of the things that go bump in the night.

These days, ghosts are a very popular subject on television, in newspapers and in books. Subjects that used to be confined to Halloween are now year-round fare. People have a renewed interest in the possibility of the paranormal, due in part to shows such as *Ghost Hunters* and *Paranormal State*, which highlight attempts at scientific investigation and the endeavors going on to capture real evidence of the unexplained. Today, paranormal investigators are compiling film and audio evidence and experimenting with changes in electromagnetic fields and temperature in allegedly haunted places to try to determine if there is objective evidence for the existence of something we might identify as a ghost.

But what, exactly, is a ghost? In the usual stories, ghosts are the disembodied spirits of the dead, and many people believe that this is what ghosts are all of the time. Most investigators believe that that is what ghosts are at least some of the time. But there are other theories to explain ghosts and hauntings:

1. Many haunting occurrences seem to be recapturing some violent or emotionally charged event in the past. This is what is called a

"residual" haunting and appears to be the most common kind. When apparitions are always observed in the same place, doing the same thing, and show no awareness of their actual surroundings or of living beings who are present, they are probably residual. These ghosts would have no personality or substance but would be the psychic equivalent of holograms, replaying one small bit of history. An example of this might be the well-known ghost of Alice, at the Hermitage near Myrtle Beach, South Carolina. Many of the sightings around Marietta, especially of Cherokee braves and Civil War soldiers, seem to be of this type. There can also be residual sounds, such as the beating of drums or wailing of doomed souls that will be encountered in several of the stories in this book.
2. Some parapsychologists and others postulate that ghosts may be a projection of our own thoughts. Since we use only a small part of our brains, some people theorize that certain circumstances, combined with a certain frame of mind, will trigger an extremely vivid vision that appears to be real in every way. Anyone who has ever experienced a hallucinogenic drug will concur that reality can often be a tricky thing. One problem with this theory is the attempt to explain how such a manifestation might be caught on film or tape, as they often are. Another is that, very often, more than one person sees or hears the same image or sound, which would require some sort of collective hallucination.
3. People of a particular religious background who laugh at the idea of ghosts may be much more willing to believe that ghosts are angels, demons or remnants of the ancient fallen angels known in Genesis as the Nephilim. To these people, something unknown is either supernaturally good or supernaturally evil. In most cases of haunting, there is little evidence of either extreme, and in the case of repetitive, residual haunting, this theory makes little sense.
4. Another theory is that ghosts may actually be aliens from outer space, though why they would take forms from throughout history or hang about in places that are often empty for most of the time (such as abandoned jails and hospitals) is hard to understand.
5. An interesting new theory is that at least some ghosts may be glimpses into another dimension. String theory has brought new popularity to this idea. In string theory, one conjecture is that there are many dimensions, not just the ones we are familiar with. Some people theorize that there may be other beings inhabiting parallel dimensions, going about their lives in similar fashion to our own, and once in a while some circumstance will create a break between

the dimensions, and we catch sight of one another. This would explain why apparitions that do appear to have intelligence and emotion sometimes seem so surprised to see us. One investigator was recently conducting an EVP session, attempting to capture communication with a spirit on tape. He asked if the spirit could hear him and got a clear answer, "Yes." He then asked the spirit if it could see him and got the reply: "No. Are you a ghost?"

None of these theories, which exclude the possibility of intelligent interaction between the spirits of the dead and the living, explain why ghosts often seem to be emotionally involved with the place where they are or with people in the place, and why so often the evidence we gather seems to indicate a real intention to communicate with us. This is especially true in EVP work. In EVPs, it is not unknown for unseen entities to actually address people by name or refer to items in the room or the building. They also often refer to specific historical events, as when the EVP was captured at the Kennesaw House that appears to say, "Watch it…Sherman's in here."

Another question that is worth pondering is: why do ghosts wear clothes? Obviously, if they no longer have physical bodies, they don't need clothes. And also, what is with all those "spirit guides" with the Native American names?

In other words, why do ghosts appear to us the way they do? Well, most of the time, they don't "appear" to us at all. If you watch a lot of paranormal shows on television or if you have participated in paranormal investigations or experienced ghostly phenomena yourself, you've probably noticed that when there appears to be intelligent interaction between people and ghosts, the ghost is almost never visible. The living person or persons will hear sounds, feel touched and see things move about but rarely see the actual apparition, or if they do see something, it's only a shadow. When someone actually sees a ghostly figure, or more than one, they seldom seem to be interactive or even aware of what is going on around them and probably don't represent any surviving spirit anymore than characters in old films or photographs.

Most of the time, when ghosts do interact with humans in a visible form, it is to a loved one, especially soon after death. There are exceptions to this, of course. People staying in haunted hotels, for instance, sometimes see apparitions in the room that may seem aware of them and interact with them. But more often, the spirit

seems to be appearing to deliver a message or to say goodbye soon after death.

So when this does happen, why are the ghosts dressed the way they are?

I think that the most likely theory is that ghosts appear to us in a form that our minds will be able to accept. We know from physics that energy is only transformed or transmitted but never destroyed. So the energy that inhabits our bodies must go somewhere when we die, but that energy probably has no actual form other than a blob of light, if it has a form at all. If, as most paranormal researchers believe, it is possible for it to manifest as a form by pulling light from other sources, such as cameras and other electrical instruments, then it may well be able to choose to manifest in whatever way the person it is manifesting for will feel least afraid of (unless it wants to scare someone, of course).

Since a naked ghost would be a scary sight indeed, the entity manifests with clothes on and looking as much like it did in life as possible. It may also be easier, or only possible, for the ghost to manifest in the form it remembers itself in most clearly, which is probably wearing clothes.

As for those Native American spirit guides, there is a widely held belief that Native Americans were more spiritually attuned than other people, especially in New Age circles. So it would make sense for spirits who have passed over and want to be helpful to manifest in a form or identify themselves as a form that will be easily accepted by the subject they wish to communicate with and through.

Of course, this is all just theoretical, and no one can say for sure what ghosts are or what the evidence captured or stories recounted really mean. However, it seems difficult to deny, in the face of the evidence, that in a small number of cases, there is intelligence and at least a shadow of recognition and emotion, attached to what we choose to call ghosts. As we discuss the ghosts of Marietta, it may be interesting to see if they behave and interact in an intelligent way or if they seem to be residual, reenacting events from the past in the stories that we explore.

A HISTORICAL MARIETTA GHOST STORY

Ghost sightings have been common in Marietta since long before the twentieth century began. Here is one told by Norris Mabry, a longtime Cobb County resident, in a little book called *Cobb County Reflections*.

Mr. Mabry recalled that in the spring of 1891, a young woman named Lula Burtz graduated from college and returned to her father's farm, which was located in the area where Sandy Plains Road now is, not far from the present location of Mountain View School. Not long afterward, Lula became sick from some mysterious ailment that mystified her doctors, a not uncommon occurrence at the time. As was also often the case, she was being cared for at home by her family, as the doctors did not know of anything they could do for her and there seemed no need to send her to the hospital. By June, it was clear that the poor young woman did not have long to live.

As was the custom of the time, relatives and friends were coming in to sit by the young woman's bedside and watch her through the night to give her family time to rest, eat and attempt to reconcile themselves to the coming loss.

On June 8, 1891, the minister, Reverend Swafford, along with Mr. Mabry's uncle and another man, had taken a turn watching the dying woman. They left at 1:00 a.m., when the next group of watchers came in to relieve them. About fifteen minutes later, as the men were

walking slowly home, having by that time gone about a quarter of a mile from the Burtz house, something strange caught their eye.

From the woods to their right, a sheet appeared, hovering over the ground. The sheet seemed to sag in the middle but to be pulled tight at the ends, although no visible hands were holding it. It floated about waist high across the road in front of the men and disappeared into the woods on their left.

The men returned to the Burtz house only to learn that Lula Burtz had died, been wrapped in a sheet and carried across the hall to another room to be prepared for the wake and the subsequent viewing at the very moment that they saw the sheet. No man ever came up with an explanation for what they had seen other than a paranormal one.

SHADES OF THE CIVIL WAR

Many people believe that ghosts, whether residual or intelligent, are more likely to linger when certain conditions of death are met. People are more likely to manifest after death if they died young, unexpectedly and in a violent manner. They are more likely to become ghosts if they have unfinished business or seek revenge. In Marietta during the Civil War, thousands of young men from both sides died suddenly and in an unexpected manner. Many were in the heat of battle; one moment they were fighting with all their strength and the next they were dead. Others died consumed with fevers in makeshift hospitals in attics and basements of houses or in overcrowded tent hospitals. Some died in prison camps. It is no wonder that so many of these spirits seem to linger all over the area.

Let us look now at some of the places in Marietta where these spirits associated with the war, both soldier and civilian, seem to linger.

THE KENNESAW HOUSE

Of all the haunted places in Marietta, the Kennesaw House may be the most fascinating. Located right next to the railroad tracks and neighbor to the historical train depot that now houses the Marietta

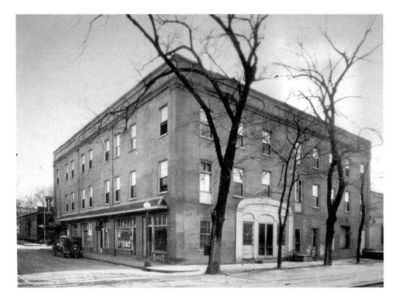

A view of the Kennesaw House in the 1920s. *Courtesy of the Marietta Museum of History.*

Welcome Center and the Old Thomas Warehouse, home to the Gone With the Wind Museum, the very location of Kennesaw House makes it easy to picture bygone times. History is in the air all around, and it is not hard to believe that shades from the past linger here or, indeed, all around the square.

The house is now the home of the Marietta Museum of History, but it was originally built in the 1840s as a cotton warehouse by John Glover, Marietta's first mayor, who owned Bushy Park, which became the 1848 House. When the railroad brought hungry visitors to town, Glover turned the warehouse into a restaurant to serve the passengers from the depot next door. In 1855, the stagecoach stop owned by Dix Fletcher had burned down in one of the three disastrous fires that beset Marietta in that era, so Mr. Fletcher bought the building and turned it into an inn, the Fletcher House. Travelers who came by stagecoach to the railroad and visitors seeking relief at the spa that was then active in Marietta stayed here, as well as planters in town for business or other visitors from the Lowcountry and the coast seeking relief from summer heat and the malaria it brought to the plantations.

When the War Between the States began, its location right next to the railroad made the Fletcher House a natural base for Union soldiers and spies, especially since Mr. Fletcher is suspected to have been a Union sympathizer, and certainly his son-in-law and nephew were on the side of the Union. It was here, in April 1862, that James Andrews and his group of spies plotted to steal a train and use it to tear up the railroads between Marietta and Atlanta before turning it over to the Union troops. On April 12, they boarded the train at Marietta and rode it, without attracting attention, to Kennesaw, where they absconded with part of the train known as the General. The wild chase that ensued became known as the Great Locomotive Chase and has been the basis for several films and many stories over the years. Andrews and most of his men were captured shortly thereafter, and Andrews and seven of his men were hanged. The other fourteen were sent to prison camps, where eight escaped. The rest were eventually paroled. Some people claim, according to the History Channel program *Haunted History*, that James Andrews may be one of the ghosts encountered today in the Kennesaw House.

In 1864, the hotel was taken over by the Union army, and Sherman briefly used it as his headquarters. This, along with the fact that Mr. Fletcher was a Mason and that his son-in-law, Henry Cole, is widely believed to have been a Yankee spy, is probably why the house was not burned in 1864, although the fourth floor caught fire from the flying ashes of the burning buildings around it and was destroyed. We will encounter Mr. Cole again in the section on the Marietta National Cemetery.

But most of the ghostly activity that occurs in the Kennesaw House seems to be the result of its use as a makeshift hospital and morgue during the war. The entire fourth floor of the house, which was never restored after the war ended, was used for this purpose by both the Union and Confederate armies during the course of the war. According to television documentaries from PBS, CNN and the History Channel, the basement may have been used for this purpose too, as they all have told the story of visitors who descended to the basement in the elevator, only to be greeted by the gruesome site of a crowded hospital room, men screaming in agony, blood everywhere, as weary surgeons operated and removed limbs with little or no anesthesia.

Barbara Duffey, the author of *Angels and Apparitions*, described what she saw for *Haunted History*:

> *My attention was drawn to the corner of the room and there materialized a scene, an operation that was going on. A large man was leaning over a table, and he had huge arms and his white shirt was rolled up high on his arms. Just as quickly as the scene appeared, it began to fade away.*

Other people have seen an apparition that appears to be a Civil War–era surgeon who seems to like to ride the elevator. Before I knew of this, I told my husband that I always got a weird sensation in that elevator, one that I had no explanation for. Some people believe that this surgeon may be Dix Fletcher's nephew, a Union doctor who is known to have treated members of the family there and probably also worked with the soldiers. The elevator is known to rise from the bottom floor to the top and open even when only one employee is in the building. Nancy Roberts, the author of *Georgia Ghosts*, actually experienced this phenomenon herself when she went to Kennesaw House to interview director Dan Cox. Mr. Cox has also mentioned seeing a figure who may be this man. In *Georgia Ghosts*, he gives the following account:

> *One winter afternoon my wife and I stood talking in front of the elevator. I happened to turn my head and see a gentleman standing right beside me…He ignored me. I could see that he was wearing a flat, black-felt hat and a cream colored coat that struck him about mid-calf. Something about the fellow reminded me of a doctor, but he disappeared so fast…*
>
> *An employee of mine was working late one afternoon, when he heard a noise in the hall. Thinking someone had wandered in by mistake, he opened the office door and stepped out to ask if he could help whoever it was. A gentleman in a coat and hat walked right by him, then disappeared.*

The description the employee gave matched the appearance of the man seen earlier by Mr. Cox.

A pleasant ghostly figure that has been seen a number of times at the Kennesaw House is a lady who wears an old-fashioned dress

trimmed in pink. She is most often seen by children, who often identify her as the lady in a portrait in the house. The portrait is of Mrs. Fletcher, Dix Fletcher's wife.

Other female figures that have been seen or heard in the house are believed to be either Mrs. Fletcher or one of the family's three daughters.

Dix Fletcher reopened the Kennesaw House in 1867, and it remained a hotel until the 1920s, when the second floor was converted to retail stores. The upper floors remained in use as a hotel until the 1970s. Then, in 1979, the building was completely gutted inside and renovated into office space. A number of businesses and several restaurants occupied the Kennesaw House for fourteen years after that. Finally, it was acquired by the Downtown Marietta Development Authority and the second and third floors were once again renovated to accommodate the Marietta Museum of History. Mr. Cox has been the museum director from the beginning. He claims to be extremely skeptical of ghosts and to think that most of the things that happen in the house can be explained—most of them.

"It's an old house," he says, "and strange things happen in old houses."

Very strange things, indeed, when one considers the case of the Kennesaw House.

Several years ago, the Ghost Hounds paranormal investigation group investigated the house and caught what appears to be the ghostly figure of a woman on film. They were investigating a staircase where some employees had heard a sound, as though someone wearing a ring were dragging her hand along the stair rail. Despite intensive scrutiny, this photo has never been explained.

Among the most compelling pieces of paranormal evidence caught at Kennesaw House are several photos captured by museum director Dan Cox, who used his digital camera to take photos of what appeared on the security cameras several times, twice in 2001 and again in 2003. Mr. Cox explained that he was in his office when he saw the odd anomalies on the camera, ran downstairs, took a picture of the screen with his digital camera and ran back up. The first security camera photo clearly shows the ghostly figure of a woman in a dress with a bustle. Another photo also shows another figure, this one shorter and with less discernable clothing.

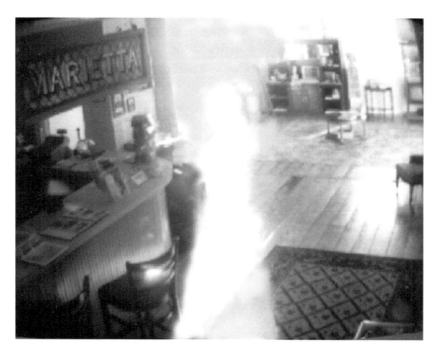

The famous Kennesaw House ghost photo. *Courtesy of the Marietta Museum of History.*

Could the woman in the clearer photo be Mrs. Fletcher, or one of the Fletcher daughters? And is she the same woman whom Cox and other employees have heard calling their names in the second-floor break room? And who is the other figure who is sometimes captured?

Mr. Cox says that he has no explanation for the pictures.

Atlanta Ghost Hunters also caught paranormal activity when they investigated in 2008, including several EVPs, one of which seems to say, "Watch it…Sherman's in here." This makes sense since, as mentioned before, Sherman did occupy the house for a while during the Atlanta Campaign. Cofounder Andy Roberts had an interesting experience on that investigation as well:

> *I was alone on the second floor of the building and started provoking the spirits. I was almost yelling at Sherman for burning Atlanta to the ground. Well, that turned out to be a bad idea, because instantly I had the worst headache I have ever had instantly start. It literally*

felt like someone had a vise grip on my head and started to tighten. I was instantly nauseous and had to leave the investigation early from feeling so sick. Before this moment, I felt perfectly fine. It was the only time I have ever experienced anything like it before or since.

Mr. Cox told me that he has read newspaper reports that claim there may be as many as seven hundred ghosts in the house. (A parapsychologist hired by the History Channel claimed there were actually one thousand.)

"I've never been frightened, never felt any cold spots or ill will. If these people are here, they are very happy. And we want to keep them happy. If there's seven hundred of 'em, we want to keep them all very happy."

Whether you encounter ghosts or not, the Kennesaw House is a handsome building and now houses an excellent museum that is well worth your visit. The museum is open from 10:00 a.m. until 4:00 p.m. Monday through Saturday. It is located just off Marietta Square next to the railroad tracks.

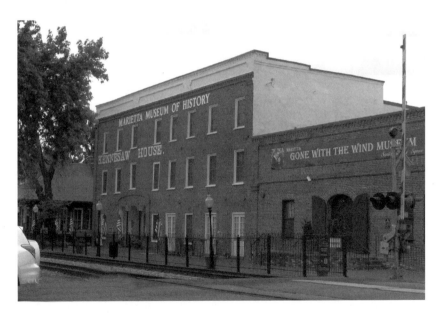

The Kennesaw House today. *Takesi Akamatsu.*

Kennesaw Mountain Battlefield National Park

On a blistering hot, clear Monday, June 27, 1864, some of the heaviest and most brutal fighting of the Atlanta Campaign of the War Between the States took place in and around the area now designated the Kennesaw Mountain Battlefield National Park. Ironically, the name "Kennesaw" derives from a Cherokee word, *Gah-nee-sah*, which means burial ground, and for many soldiers from both sides, that is what this battlefield became.

The battle began on June 19, 1864, and did not end until July 2. During its course, over 5,350 soldiers were killed, while over 60,000 more were wounded or captured.

General William T. Sherman's army consisted of 100,000 men; the Confederate army, under General Joseph E. Johnston, had 63,000. The Confederate soldiers were outnumbered and outgunned, but they were encased within a massive number of trenches and earthworks designed to confound the Union troops.

Sherman had been marching his men along the route of the railroad from Chattanooga, Tennessee, all through North Georgia,

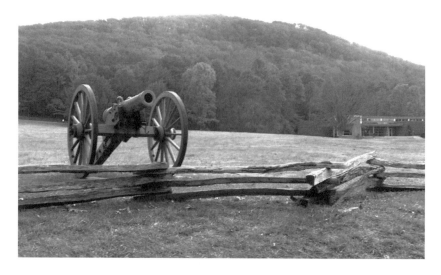

The Kennesaw Mountain Battlefield National Park. *Rhetta Akamatsu.*

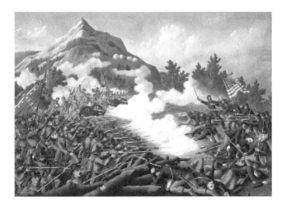

A historical depiction of the Battle of Kennesaw Mountain. *Library of Congress.*

heading for Atlanta. The railroad was imperative if Sherman was to reach Atlanta and then continue his March to the Sea. It was the supply line for food and supplies, without which the troops could not survive. Johnston and Sherman had been engaged in what author Bruce Catton once referred to as "a macabre dance." Johnston would take up a defensive position, only to retreat when Sherman's army flanked his. But at Kennesaw, this dance came to an end.

The rain that year had reached record levels. The men were traveling under the worst possible conditions. Blue and gray alike were miserable, and tempers were at the breaking point. In *The First One Hundred Years: A Brief History of Cobb County in Georgia*, Sarah Gobel Blackwell Temple describes the conditions thus:

> *Rain fell until the roads became quagmires. Wagon trains sunk to their hubs. Artillery seemed hopelessly mired. Sweating, struggling men, horses, and mules were plastered with the red mud and filled with wrath. Mules fell with broken legs or shoulders, were unhitched and left in the mud, from which their decaying bones protruded grotesquely as heavy wagons churned their way this way or that.*

At Kolb's Farm, a few miles from the main battlefield, the Confederate forces attacked Sherman's troops. I will discuss the battle at Kolb's Farm in more detail in the next section. The attack, under Lieutenant General John Hood, was turned back, but Sherman could no longer get around the Southern troops. It was time to stand and fight.

Early on June 27, the morning calm erupted as artillery and cannon fire ripped through the air. Then, the Union infantry began

assaulting the dug-in boys in gray from three directions: the Army of the Cumberland in the center, the Army of the Tennessee to the left and the Army of the Ohio from the right. Corporal Benjamin F. McGee, Seventy-second Indiana Infantry, recorded his impressions in his *History of the 72d Indiana Volunteer Infantry of the Mounted Lighting Brigade* thus: "Every mountain and hill, in front and far away to the right, fairly bristled with artillery and swarmed with Rebels. Never before had we seen so many Rebels at one time."

Despite every intense effort, with dead and wounded falling on both sides, the Union soldiers could not overcome the fortifications, the mud and the treacherous terrain to dislodge the Confederate soldiers. At the point of the fiercest fighting, near the center of the line, the slaughter was so horrific that the area became known as the Dead Angle. Private Sam R. Watkins, First Tennessee Infantry, Maney's Brigade, wrote a memoir called *Company Aytch* in which he recalled:

> *A solid line of fire right from the muzzles of the Yankee guns, the hot blood of our dead and wounded spurting on us, the blinding smoke and stifling atmosphere filling our eyes and mouths...afterward, I heard a soldier saying that he thought "Hell had broke loose in Georgia, sure enough."*

So many soldiers died or were wounded at the Dead Angle that Captain David P. Conyngham, Volunteer Aide-de-Camp of the Federal Staff reported in *Sherman's March Through the South*: "Next day, General Johnston sent a flag of truce to Sherman in order to give him time to carry off the wounded and bury the dead, who were festering in front of their line." In all, three thousand Union soldiers and one thousand Confederate soldiers died at Kennesaw Mountain, while more died later of injuries sustained.

Although the battle was deemed a victory for the Confederate side, it did not stop Sherman in the long run. Shortly after this battle, the Union army was again able to flank the Confederate troops and continue the ultimately successful march to Atlanta. Many historians consider that the entire Battle of Kennesaw Mountain was a needless waste of lives.

These are the facts. Behind those facts is the tragedy. On both sides, the average age of these young men was just twenty-six, with some as young as eighteen and many who lied about their ages and were much

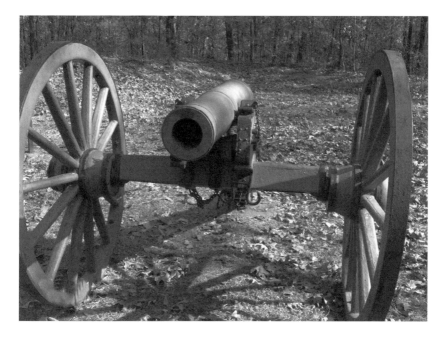

Cannons at Kennesaw Battlefield today. *Rhetta Akamatsu.*

younger than that. Most, on both sides, had been farmers before the war; very few on either side had been in the military. In an instant, thousands of them were killed and many thousands more permanently maimed for a battle that essentially did nothing for either cause.

It is no wonder, then, that some of these soldiers linger here in spirit, as they do at every major Civil War battlefield and no doubt countless other unsung battle locations throughout the country. Visitors have reported seeing ghostly soldiers and hearing the distant sound of gunfire. Sometimes those who live nearby report the sound of cannons at night. Deer are said to run at people, only to disappear in front of their faces. Phantom smells of blood and gunpowder are also reported.

Very recently, a report appeared on WXIA (11 Alive) news about a man and his teenage son, who wished to remain anonymous, who said that while driving through Kennesaw Mountain Battlefield at night, a horse and rider suddenly appeared in front of their car and crossed the road. The man and his son are both Civil War buffs and recognized the rider as being a Union officer, with a saber in his hand.

"I quickly locked down on my brakes as the horse proceeded to come right in front of us," the driver told the news crew. He said that the rider then headed straight through a fence as though it didn't exist and faded into thin air. "My son and I were in a state of almost sheer panic," the man recalled, "but we managed to maintain and get on the way home very quickly."

This incident made the news, but it is far from being the only incidence of strange sightings and experiences at the battlefield. While attending a convention in Alabama, a Civil War reenactor told me a story about a young reenactor who was able to see ghosts near Cheatham Hill, at the battlefield. I found a retelling of the story in the book *Ghosts of War*. What follows is the story as it was told to me and reported in *Ghosts of War*.

On a summer night in June 2000, a group of Civil War reenactors were encamped at Kennesaw Battlefield. They had all heard stories of ghosts at Kennesaw Mountain, and just for fun, a few of them decided to go "haint" hunting. ("Haint" is an old southern term for a ghost.) The group consisted of several men and a boy who was about twelve years old at the time. After searching for a while and seeing nothing, they grew bored and started back to camp. At one point, they decided to put out the lantern they had with them and proceed in darkness, just for the thrill of it.

It was at this point, near Cheatham Hill, that the boy began to shake and cry. He said that he saw men lying on the ground, all burned up. He was "hollerin' and carryin' on" and talking about how horrible it was. The men were spooked and rushed back to camp. That was the end of their "haint" hunting for that night and every night to come. (It is interesting to note that next to the road near the spot where the boy saw the burned-up ghosts, there is a marker that tells about the brush fires that broke out and burned many wounded and dying men to death.)

Many writers and speakers on the subject of the paranormal believe that Civil War reenactors are among the most likely people to experience ghosts on a battlefield because, by placing themselves in the clothing, setting and mindset of the experience and attempting to relive conditions as closely as they can, they are opening themselves up to whatever spirits, residual or intelligent, may be present there.

Kennesaw Mountain National Battlefield began its life as a memorial site when the State of Illinois purchased a small section

of land near Cheatham Hill, where so many brave soldiers from that state lost their lives, and erected the Illinois Monument, which was completed in 1914. The area around this monument has often been cited as a center for ghostly activity, including the sound of whispering and strange mists.

Not all of the ghostly activity found at Kennesaw Mountain Battlefield is the result of the War Between the States. Before this land was a battlefield, it was occupied by Mound Builders and then by their descendants, the Creek Indians, until about 1750, when the Creeks were pushed out of Georgia by the Cherokees. The Cherokees were then forcibly evicted in 1838, during the Georgia Gold Rush, and marched to Oklahoma on the infamous Trail of Tears, a horrid trek along which many died of disease, starvation and exposure. Some say that before they left, they cursed the land that had been their burial ground.

The Creeks, who lived here first, were a very spiritual people with three classes of medicine men: the "seekers," who had psychic powers; those who could control the weather; and the witches, who caused murder and mayhem. What remnants might they have left behind?

The Cherokees had used the land as a burial ground, as the name shows. What spirits may be lingering there from those days, bemoaning the loss of their ancestors and the denigration of their sacred ground?

For whatever reason, apparitions in Native American dress have been seen and the sounds of war drums and Indians chanting have also been heard at the battlefield and its surrounding area.

All of the ghosts at Kennesaw Mountain Battlefield so far seem to be residual. We can hope that all of the souls who suffered and died there have moved on, leaving only insubstantial traces of the past to replay in that place of death, fear and suffering.

Kolb's Farm

As mentioned earlier, Kolb's Farm, on Powder Springs Road about three miles from downtown Marietta, is the site of the first battle that led to the Battle of Kennesaw Mountain.

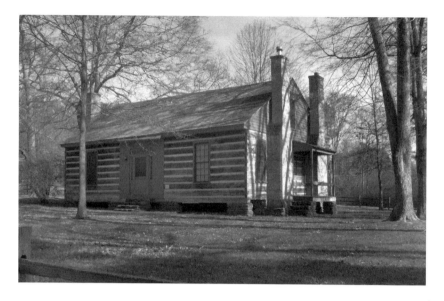

The Kolb Farm site, with a restored farmhouse. *Rhetta Akamatsu.*

The farm and the sole remaining house that stands at the site now was built by Peter Valentine Kolb in 1836. While the house looks modest to us today, it was quite opulent for the time, about twice the size of most houses of the day, with four rooms and double chimneys, a very rare feature. It was altered considerably after the war but has now been restored to its original appearance.

There was, in 1864, when the Battle of Kolb's Farm occurred, something of a battle of wills going on between General John Bell Hood and General Joseph E. Johnston. Johnston believed in delaying tactics meant to hinder Sherman in his bid to reach Atlanta and commandeer the railroad and in attacking and retreating until he could find a place to entrench his men and possibly suffer less catastrophic losses against Sherman's more numerous and better-equipped forces.

Hood, on the other hand, did not believe in delaying tactics or in entrenchment. He believed in attacking and attacking continually, no matter what the cost, in order to win. He was impatient with delay, and his thinking was more in line with Sherman's "War is Hell," do whatever it takes approach. He was impetuous and did not always let his commanding officer know what he planned to do before he did it.

When Johnston arrived at Kennesaw Mountain, he set about building a series of trenches and fortifications that gave him the strongest defensive position he had had in this part of Georgia.

Sherman's army planned to attack. It was a last-ditch effort to break the Confederate line, secure the railroad and clear the way to Atlanta, a chance to end the "macabre dance" the two armies had been conducting throughout Tennessee and Georgia. Under Johnston's orders, Hood took a division and marched to the extreme left of the Confederate line, camping along Powder Springs Road. For two days, in pouring rain, they waited, soaked, miserable and listening to the artillery fire and the cannons' roar from skirmishes all around them.

Finally, on June 22, without informing Johnston of his plans or awaiting orders, Hood decided to attack what he believed would be a weaker part of Sherman's forces—the right flank—in the hopes of turning them, so that his troops could take position behind Sherman and trap the Union soldiers between his men and Johnston's two corps. It was a typically reckless decision, and one that earned Hood great criticism after the battle.

At noon, the Confederate soldiers began moving down Powder Springs Road, with minor skirmishes along the way. In early afternoon, they reached Kolb's Farm. Here, they came face to face with two Union regiments. In the quagmire of mud from two weeks of incessant rain, heavy fighting ensued; men slipped and slid as they fought with cannon and musket. Again and again, the Confederates were repulsed, and Hood ordered them to regroup and fight on. The wounded and dying piled up, with losses especially heavy among the Confederate soldiers. Only with darkness did the battle end.

Despite his heavy losses, Hood claimed victory, saying that his men had driven the Union forces back to their reserve line and would have routed

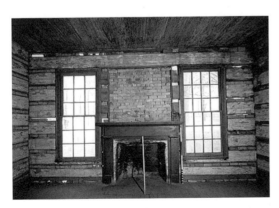

A view of the interior of the house taken during the restoration. *Library of Congress.*

them had darkness not fallen. In reality, the Confederate forces lost in excess of 1,000 men, while the Union lost only 350, and the entire endeavor accomplished nothing of any significance in the long run except a legacy of ghostly activity that includes spirit manifestations of both blue and gray throughout the entire Kolb Farm area.

As Wayne C. Bengston recorded in the article "The Battle of Kolb's Farm" at the *About North Georgia* website, General Johnston later said, "Hood had his moment of glory and reclaimed his reputation as an aggressive commander, but at a cost the Confederacy could ill afford."

There is another legend of Kolb's Farm that does not stem from the actual Battle of Kolb's Farm, but, according to the book *Georgia Folklore*, from the time slightly before that when Mr. Kolb was called for service in the Georgia Militia. Four of his slaves decided to take his absence as an opportunity to make a desperate bid for freedom, attempting to escape in the night to Northern Virginia. Their escape was foiled, and the neighboring slave owners around Kolb Farm, who were already filled with anxiety at the thought of losing their entire way of life, insisted that the slaves must be hanged in order to discourage any other slaves who might think of attempting to run away. Their sentence was carried out on August 26, 1863, when all four were hanged from a large tree on the property. Legend has it that this gnarled old tree still stands near the Kolb farmhouse today. According to *Georgia Folklore*, some people have claimed that sometimes at night, those nearby can hear the wailing and screaming of the slaves and see the bodies dangling among the leaves by the light of the moon.

If there is truth to this story, it seems unlikely that Mr. Kolb was called to the militia, since he would have been over fifty years old. However, he died in December 1863, so the slaves may have taken advantage of his ill health to attempt to escape. There were not a lot of slaves in the Marietta area at that time, but there were enough that the white owners, surrounded by so much death and destruction, may have been terrified enough to give this story veracity.

The original farmhouse, which still stands at Kolb Farm's original site and has been restored to its original appearance, is not open to the public, although the grounds are. The family burial plot is right next to the road and easily accessible, and there are several historical markers. Kolb Farm itself is a lovely and peaceful place; it seems that

the family rests quietly. It is the soldiers in the area surrounding the farmhouse who are restless or possibly the spirits of the unfortunate slaves who may have died there.

A great deal of the Kolb Farm location has been turned into highway and subdivisions, first with houses and more recently with condos springing up on the former farmland. It has been this proliferation of houses that has led to most of the ghost sightings and other paranormal activity around Kolb Farm. Much of the activity seems to center on one subdivision, known as Kolb Ridge Court.

In the book *Haunted America* by Beth Scott and Michael Norman, the story of Katherine and Michael Tatum is recounted. The story is also told in various places on the Internet.

The Tatums moved to a lovely new house in Kolb Ridge Court in 1986. They were northern transplants and had little prior knowledge of the area.

For the first year, nothing unusual happened. They were happy in their new house. Then, strange things began to occur. One night, Katherine got up to go to the bathroom. Through the open bathroom door, she saw a man walking down the hall. She assumed it was her husband, looking for her, but when she got back to the bedroom, he was snug in bed. She asked him if he had been in the hall, and he told her he had not. When she told him what she had seen, he thought that a robber had somehow gained entrance. James grabbed his gun and went to check the entire house, including all the doors and windows. Everything was secure, and there was no sign of anyone in the house.

In the months that followed, Katherine Tatum was plagued by mysterious noises and even felt physical tugs on her clothing, as well as cold spots in the house. At one point, a small angel bell the couple kept in a guest room began to ring on its own, not once but on numerous occasions. Visitors also heard strange, unexplainable noises. On one occasion when Mr. Tatum had been making repairs to the house, Katherine kept hearing the sound of a drill being turned on and off. When she went to check, the drill was lying of the floor, unplugged.

While Katherine was not able to tell the nature or color of the clothing of the ghostly figure she had seen, when she learned of the history of the location of her home, she came to feel that their house was haunted by a soldier who was involved in the Kolb Farm

battle. Reports on the Internet state that the house was still haunted as late as 2006, and at that time the Tatums had learned to live with their ghost.

Other residents have also reported seeing apparitions in and around their homes or condos, and many residents claim to have seen shadowy figures flitting through the woods that still stand on part of the land beside and in back of the houses.

In addition, several employees of a store located on land near Kolb Farm have told me that they have had many odd occurrences in the store. During the Battle of Kolb's Farm, cannons were located at the top of the hill that borders the present road, between the store's parking lot and the road. A house on a hill across the road, known as Melora or the McAdoo House, was used as headquarters for Union general Schofield during the battle. Fighting went on all around the present store location during the march to the farm. Three employees who were not known to each other told me their stories two years apart, and during that time the store changed ownership, yet the stories are very similar.

In each case, the employees reported that while working in the storeroom at night they often heard the sound of quiet whispering from some source they could not see. One employee also said that when the manager was locking up the back door in the storeroom for the night, she heard sounds outside of orders being given in hushed tones, and she was able to hear that the orders were military in nature and sounded like battle strategy. When she opened the door and checked all around the back of the store, she never saw any person or thing that could have made the noises. Another employee told me that on at least one occasion, items flew off of the shelves—not from the front of the shelves but from behind other merchandise that remained undisturbed—and crashed to the floor while he was alone in the store and in the storage room, nowhere near the merchandise. He had just checked to make sure that the shelves were neatly stocked, with no holes in the line of merchandise, before entering the back room, and yet there was a hole in the middle row of the shelf. He could not figure out how the merchandise could have fallen from the middle of the shelf without disturbing the front.

Other Civil War Ghosts

The Kennesaw Battlefield, the Kennesaw House and the Kolb Farm area are not the only houses in Marietta that have been visited by spirits from the bloody battles of the Civil War, however. In fact, there is hardly a residential area of the city that does not have its own ghost stories.

For instance, one incident of unexpected Civil War visitors is recounted by a young woman whose family moved to Marietta in 2000. Misha Kantartzis has told her story in various places on the Internet and in a book called *Ghosts of War* by Jeff Balenger.

Ms. Kantartzis said that as soon as she and her family moved into their new house, which had a view of Kennesaw Mountain, she began to experience things that disturbed and frightened her. She felt as though there was another presence in the house right away. Doors would open before she had a chance to reach for the doorknobs. Windows that had locks to keep them open would suddenly slam shut. Lights would flicker, and she would catch sudden glimpses of blurry figures out of the corner of her eye, particularly in the backyard.

About two weeks after moving into the house, Misha had an encounter with a figure she took to be an officer in a blue uniform:

> *I saw him clear as a bell. It kind of shocked me. He was two feet away from me, and it was full-figure, too. I noticed the emblems he had on the shoulders—that's what led me to believe he was a general because of what he was wearing. He was definitely in charge. But the thing was, he wasn't aware of me. Almost like I was watching a movie or something. He seemed real agitated, like he was barking out orders or something—that was the impression I got. He was gone in a matter of seconds.*

Another amazing sight happened one day as she was cleaning the stairway of her house. This is how she described her experience on the Ghost Village website:

> *By far the most frightening experience occurred last summer, as I finished cleaning upstairs and made my way down the staircase. I was mopping the wooden stairs and I saw a movement out of*

the corner of my eye outside the window located at the bottom of the stairs. There is a full-length mirror that hangs adjacent to the window giving you a nice view of the backyard. I stopped mopping and really looked out the window and to my amazement I saw a hundred legs, all clothed in blue marching past the window! At first I just stood there trying to convince myself I wasn't seeing them, and they just vanished!

At other times, Misha also sensed the presence of one soldier in a blue uniform, whom she felt was named John and nicknamed Blackjack. She thought it was odd that he appeared to be a Union soldier rather than a Confederate one, until she learned that the house stands very near an area where there was a makeshift Union hospital, one of the many that dotted the landscape. While John seemed harmless enough, she and her daughter also sensed another, angrier, spirit. Her daughter had seen what she believed to be this spirit, and she said that he had red hair, dark eyes and seemed angry and decidedly unfriendly.

Misha and her family moved out of the house in 2003, and the house has been torn down. The area was slated for commercial development in 2006 and may well now be covered with new houses or condominiums. In 1864, it was a campsite and a tent hospital for Union soldiers, and it will be interesting to see if reports come out of new habitations within sight of Kennesaw Mountain of unexpected visits by Union officers and phantom regiments.

Not all Civil War–era ghosts are soldiers. The playful ghost that inhabits a warehouse near Sandy Plains Road and Canton Road seems to spring from that era, as well. But far from being a soldier, this friendly, mischievous, giggly spirit seems to be that of a little girl, about ten years old, with long, blonde curls. She wears a long dress of the type that girls wore in the 1800s, and she loves to run through the racks and hide in corners of the warehouse. A number of employees have seen her, and they believe that her name is Chloe, although no one is sure why they think this is so; it's just a feeling they have.

This is an area that is often identified as being the former site of another makeshift hospital during the war. It is difficult to confirm if these houses, which became hospitals or were inhabited by soldiers, actually existed in these places, as they were either destroyed by the war or have been demolished long since. However, this area is one of

the most active areas of the city from a paranormal standpoint, and other spirits have been seen in and around the building that do seem to be soldiers dressed in gray uniforms.

It seems odd that a young girl would be connected to a Civil War hospital, but, after all, most of these "hospitals" were merely houses or businesses that had been commandeered or volunteered for the service, with so many wounded and dying and so few facilities for caring for them. Perhaps Chloe was a child who lived in the house that became a hospital, or she could have been the child of a doctor or volunteer at the hospital. It is impossible to know, but the employees of the warehouse feel that she is a happy spirit, and most seem to have more or less adopted her and to rather enjoy her presence.

Most of the Civil War–era ghosts that are sighted around Marietta seem to be residual and do not interact with, nor are they aware of, their surroundings. The ghost that turned doorknobs and opened doors at Ms. Kantartzis's house may have been a real spirit with the ability to attempt to interact with the living, while the officer and the feet she saw marching past her window were almost certainly residual. Chloe seems to be highly interactive and loves to play with the employees of the warehouse.

CEMETERY SHADES

Marietta has several cemeteries, both public and private, that seem to have entities of some sort hovering about them. It is fairly rare for spirits to linger in cemeteries, despite popular depiction. It seems that very often the spirits that do linger in graveyards are not those of the departed but those of mourners, and these are probably residual, the images captured there by their grief and despair in those moments of loss. It is much more common for ghosts to haunt places where they lived and to which they were attached or the places where they met sudden death.

However, Marietta Confederate Cemetery and National Cemetery both have ghost sightings, with the Confederate Cemetery having more. This cemetery's history of sightings almost dates back to the very first burials in the cemetery. The sexton in the late 1800s reported often seeing soldiers wandering among the graves or marching back and forth. Why should this be?

Many times, in both cemeteries, the soldiers have seemed to be standing guard. It is possible that they may not realize that the war has ended and their duty is over. This may especially have been true with the early sightings. Perhaps it took a while for the soldiers' spirits to realize that they were dead.

Also, many of these soldiers died on battlefields far from their homes. Their spirits may have been confused and not able to return to their homes. There is so much we don't know about this area, and

that is why we take pictures, listen to the EVPs and try to communicate in any way we can, so that we can understand why these images and voices linger and, if need be, help them to move on.

In addition to the Civil War cemeteries, the area has at least two cemeteries, the Devil's Turnaround and the Witch's Graveyard, that are not peaceful places and cause many sensitives and other visitors to feel uneasy. Strange mists, cold spots, battery drains and other possible signs of paranormal activity are common. I wonder if some of the reason for this activity may be that the places have been tagged with these very negative names. Perhaps some of the inhabitants do not appreciate being associated with the devil and with black magic. Perhaps the people who come into these graveyards illegally to sell drugs or practice Satanist rituals are stirring up dark energies.

In St. James Cemetery, we encounter a type of paranormal activity that is found in and out of cemeteries with great regularity: seemingly haunted statuary. There are stories of haunted tombstones, haunted statues and even haunted benches all over the country. Augusta, Georgia, has a famous Haunted Pillar. Statues of the Virgin Mary that cry are one of the most common forms of ghost story. There are several statues of the Virgin Mary that allegedly cry in the St. James Cemetery, and for that matter, in the Marietta National Cemetery as well. Why should this be?

There may be a natural explanation: the moisture collects in and around the eyes of the statues, and they appear to cry. Of course, there are also images that appear on tombstones and strange lights. Another reason, one that I, as a sensitive, endorse, is that natural substances such as wood and stone seem to absorb psychic energy and store it more easily, and these phenomena may be manifestations of the release of that energy.

St. James Episcopal Cemetery

St. James Episcopal Cemetery is the resting place of JonBenet Ramsey, her half sister and her mother, Patsy, but the paranormal activity in the cemetery dates back to long before JonBenet's

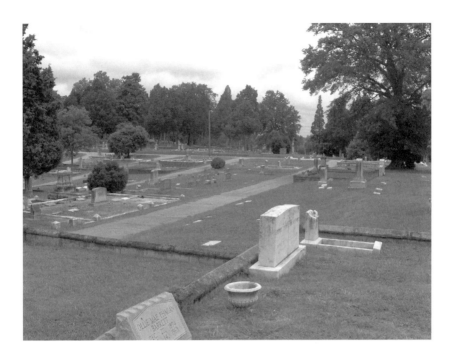

St. James Episcopal Cemetery. *Crystal Pinson.*

tragic death, and while there have been reports of EVPs being captured of a young girl saying "Mommy" in that area, these may well be from the well-documented ghost of another young girl that has been seen in the cemetery many times. There has, to my knowledge, been no reason to think that this little girl, her mother and half sister, who are all buried under a tree hung with hundreds of bright angel figures, do not rest peacefully in their graves. That may not be true of all of the inhabitants of St. James Cemetery, however.

St. James Episcopal Church was established in 1842 by engineers who were working on the railroad, pharmacist William Root and some other influential Marietta citizens of the day. In 1849, the church began a "grave-land" at the corner of Winn Street and present Polk Street. The first burial took place in 1850. Today, the cemetery is still in use and is very well maintained.

In the St. James Cemetery, there is a large marble statue of a woman who cradles two infant children in her arms. This is the statue of Marion (also sometimes called Mary) Meinert, and the

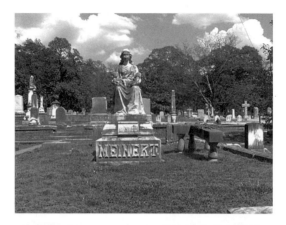

The statue of Marion Meinert, said to weep at times. *Crystal Pinson.*

residents of Marietta have long told the story of how the statue weeps at times—Mary weeping for her children. Some people say that this especially happens when the date of their deaths, October 13, falls on a rainy Friday, and only at midnight, while others say it happens on nights with a full moon. Certainly, the statue is very evocative, and it is not hard to imagine that it may cry. The image of Marion and the figures of the two children have been disfigured by time and weather but remain beautiful.

There are several stories recounted of how Marion and the children met their deaths. One story says that they all died as Marion struggled to give birth to the twins. Another story says that they lived in a large house that burned, and they died in the fire. There is no indication on the monuments at the grave of the cause of death.

Among teenagers, there is a legend that if one visits the grave at midnight on Halloween and circles the statue three times, chanting, "Mary, Mary, how did your children die?" the heartbroken spirit will appear. This is no doubt apocryphal, as these legends generally are, and if it were to be true, it would be cruel and disrespectful to do such a thing.

Another touching spirit seen in this cemetery is that of young girl with no shoes, often seen crying near her parents' grave.

A local paranormal investigation team made two visits to St. James Episcopal Cemetery in 2005 and did get some results. Members recorded EVPs of a little girl saying "Mommy." Two investigators also had their camera batteries die at the same time near the statue of Marion Meinert, and several investigators reported hearing what sounded like footsteps near a tree in the cemetery.

Over all, St. James is a beautiful, well-cared-for and peaceful place. The statue of Marion and her children is poignant, and the story of the child with no shoes is touching, but there is nothing threatening or uncomfortable here.

There are also said to be several statues of the Virgin Mary here that also cry, but as there are said to be such statues in nearly every graveyard—and because of the story of the Marion Meinert statue—I believe these may be apocryphal.

Marietta City Cemetery and the Confederate Cemetery

Marietta City Cemetery, located off Powder Springs Road near the square, was established in the 1830s, while the town was still tiny and new. It is the resting place of a wide range of Marietta citizens—from the wealthy and influential to the middle class and the poor—and contains a marked section for slave graves as well. In the 1800s, no other major cemetery in the South had a separate lot for slaves and former slaves. Nineteen slaves and freed persons of color are buried there, although only four have been positively named.

There are few of the usual boundaries that separate race or social status in Marietta City Cemetery. Workers, planters, ladies, merchants, politicians, slaves and many, many children all share the serene and peaceful resting place. Only the Confederate dead have a completely separate place.

It is interesting to note that the existence of the slave lot would have been lost to history in the chaos following the "Late Unpleasantness," as the Civil War was often known around here, if not for the efforts of a disabled Civil War veteran who was the city clerk of Marietta, Robert E. Longhorn. Longhorn attempted to put together a complete cemetery record, and due to his diligence, the existence and location of the plot were preserved.

The Confederate Cemetery was added adjacent to the City Cemetery, at the top of the hill overlooking the square, in 1863. It was originally intended only as the final resting place for twenty Confederate soldiers killed in a train wreck in Marietta. However, according to the cemetery's official brochure, after the war was over, the Georgia legislature "appropriated $3,500 to collect the remains of Confederate soldiers who fell elsewhere in Georgia and return them to Marietta for reburial." This, as we shall see, was done through the efforts of certain ladies of Marietta.

The actual recovery effort was spearheaded by two women, Catherine Winn of the Ladies' Aid Society and Mary Green from the Georgia Memorial Association, and carried out by groups of women who searched battlefields at Kennesaw Mountain, Kolb Farm, Ringgold, Chickamauga and many more fields north of the Chattahoochee River. The determination and bravery of these

women, the "fragile flowers of the South" before the war, provided marked graves for hundreds of soldiers who would otherwise have had no lasting memorial.

Later, several thousand soldiers from every Confederate state, plus Kentucky, Maryland and Missouri, who had died in the war throughout the area were brought to the cemetery and buried there, along with those who had been killed at Kennesaw Mountain and at Kolb's Farm. The graves were marked by wooden markers. By 1902, these markers had deteriorated badly, and many names were lost for all time. At that time, the Confederate Cemetery was so badly maintained, due to lack of funds, that it has been said that the bones of the dead could be seen sticking up along the banks of the road. Is it any wonder that these souls did not rest easy and that their spirits were often seen roaming in the cemetery in those days?

It was mainly through the efforts of one woman, Mattie Harris Lyon, that this situation was corrected. "Miss Mattie" was the head of the Ladies' Memorial Foundation, and as such, she pressured the state to fence the graveyard and to place stones at the graves. There is a monument to her memory in the cemetery.

The graves are now marked by rows of tiny, plain marble markers, arranged by state, with as much information as possible about the inhabitants, often pitifully little indeed, and with no guarantee that that information actually corresponds to the grave it is placed above, but at least the men have a dignified and beautiful place for their bones to rest.

The land on which the Confederate Cemetery rests was once the site of the first church in Marietta, a Baptist church that later moved closer to the square. John Glover, Marietta's first mayor, bought the plot in 1847. His widow officially donated the plot to the "Memorial Association" in 1867, by which time it had already been used for Confederate burial for four years. The plan had originally been to bury both Confederate and Union dead in the National Cemetery established that year, which is now located near the Central Library off the square, but Marietta citizens and war veterans were horrified and outraged at the idea of burying Confederate and Yankee dead together. As it was, a line of trees, now no longer there, had been planted along one side of the square in Marietta so that the citizens would not have to see the Yankee graves in the National Cemetery.

This cemetery became the first place in the South where the Confederate flag was allowed to fly, following the Spanish-American War in the early 1900s.

Despite all efforts, in the years following the Civil War, some graves were inevitably lost. One visitor to the Confederate Cemetery recorded an incident on the Haunted Georgia blog in which he and a friend recorded an EVP in the Confederate Cemetery. His friend asked where the unmarked graves would be, and a voice on the tape whispered what sounded like, "Everywhere."

Cemetery sextons have been reporting seeing ghosts in the City Cemetery and the Confederate Cemetery at least since 1895. According to the official Marietta City Cemetery and Confederate Cemetery brochure, at that time, Sexton Sanford Gorham made the first recorded ghost report. He said that as he was working, he saw a man dressed in black watching him. When he approached the man, the man vanished, although he had been standing in an open space and there was no place he could have hidden and nothing to obscure the sexton's view.

Some years later, Sexton Gorham reported seeing a woman dressed in black standing with her head bowed and shoulders drooping beside a new grave. When he approached her to ask if he could be of assistance, she also disappeared, and although it had been raining, there were no footprints in the wet ground near the grave.

That lady in black is not, however, the most famous lady in mourning in Marietta. If you look for the statue of a guardian angel in the cemetery, you will find a fifteen-foot-tall marble memorial, the physical evidence of one of Marietta's favorite legends, "The Lady in Black." This memorial was erected by Lucy Gartrell, as a memorial to her sister, Mary Anne. Lucy faithfully visited her sister's grave at least twice a week for forty-six years, and she never failed to wear black. The tale is told on the historical marker at the site. Would it be so surprising if she were to continue to visit after such a lifetime of devotion? And indeed, there are those who claim to have seen her still, dressed in black, standing stooped with grief by the grave.

In the Confederate Cemetery, many people from the earliest days of the interments have reported seeing soldiers in uniform, some appearing to be standing guard over the graves, others wandering seemingly lost among the stones. Some of these reports came from

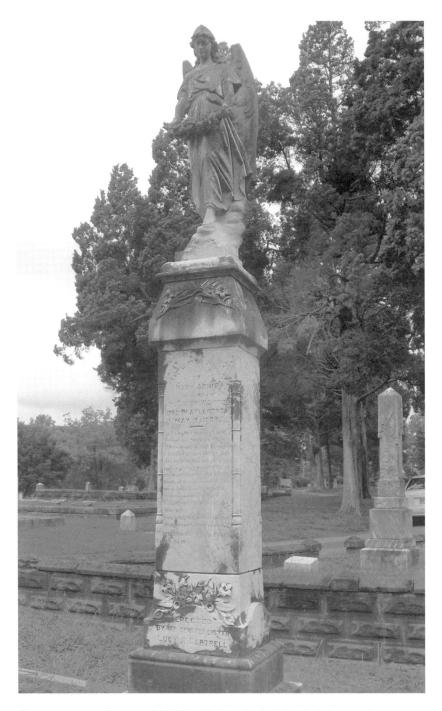

The monument to her sister faithfully visited by the Lady in Black for over forty years. *Takesi Akamatsu*.

sextons and cemetery workers from the last days of the 1800s and the early 1900s, and the sightings have become less common in recent years, although one does occasionally surface even now. The passage of time does seem to be bringing more peace to the restless spirits among these brave boys and men.

Another story from the Internet, which seems to be about Marietta City Cemetery, although the man who reported it was not from the area and was not sure which cemetery he was passing, is certainly intriguing enough to share.

The man, who identifies himself as Steve, reports that in 1997, he was driving through Marietta to get to his new home in Fair Oaks, having only moved to the area about a week before. As he tried to figure out where he was going, he passed several large houses and then came to the entrance to a cemetery.

Suddenly, a small figure appeared in the middle of the road in front of the car. Steve was sure he was going to hit her, even though he slammed on the brakes.

But nothing happened. There was no sound, no scream, no thud. He awakened his sleeping wife, who did not see anything. Then he got out of the car and looked around, but to his relief there was no small body in the road and no trace of blood or other sign that anything had ever been in the road.

That night, the man dreamed, and in his dream he saw the same scene. This time he felt sure that the figure was a young girl wearing a loose pink dress of an old-fashioned style, with eyes that were either gray or brown and blonde hair.

Steve returned to the cemetery the next day but saw nothing at the scene, just an old man sitting on a bench near the road.

The description of the cemetery fits Marietta City Cemetery. Steve believes to this day that he saw a ghost.

Despite these lingering shades, Marietta City Cemetery is for the most part a very peaceful and beautiful place to wander, and these shades, while melancholy, do not have any feeling of menace to them. That is not the case with every Marietta cemetery, however, as we will see in later entries.

Marietta National Cemetery

It has only been in recent years that there have been any written reports of ghosts in the Marietta National Cemetery, where the Union dead are buried. This is not surprising. After the dreadful war, the citizens of Marietta planted trees along the side of the square so that they would not have to see the rows of Union dead. They refused to bury their boys in gray alongside the Yankees and created the Confederate Cemetery instead. If there were ghosts of Union soldiers roaming the neat rows of graves in the Union Cemetery, the people of Marietta would have done their very best to ignore them, as they wanted to ignore every reminder of the Union occupation of the town.

In recent years, however, there have been reports of soldiers still patrolling in the cemetery, as though unaware that their duty is finished, and of the sound of marching, drums and even gunshots echoing from behind the cemetery walls.

The cemetery was originally known as the Marietta and Atlanta National Cemetery. It was originally established in 1866 to be the final resting place of over ten thousand Union dead killed during Sherman's Atlanta Campaign. It contains one of five monumental, thirty-five-foot, Roman-style archways that were used for national cemeteries of the period. The other four are in Arlington, Nashville, Vicksburg and Chattanooga.

The land for the cemetery was donated by Henry Cole, a Marietta merchant and son-in-law of Dix Fletcher (the owner of the Kennesaw House), who had remained loyal to the Union during the war. Cole was widely believed to have been a Union spy, and he had been arrested and held prisoner for a while near the end of the war before being paroled. He originally offered land to build a cemetery for the fallen heroes of the North and South, hoping that burying the dead together would help heal the wounds of the living and mend the country. This offer was bitterly rejected by both sides. In 1867, Cole offered the land again, this time for burial of the Union dead only, and this offer was accepted.

Cole had turned down an offer of $50,000 for the land, which had once been proposed as the location for the Confederate capital of the United States had the fortunes of war gone another way. Cole

said that he wanted the land to be used for a "better purpose," and in recognition of his generosity and patriotism, the U.S. government set aside a portion of land for him and his family, the only nonmilitary burials in the cemetery.

The original burials were of soldiers who had been buried where they fell. Over three years, bodies were disinterred from battlefields from Dalton to Augusta and reburied in the national cemetery. They were originally buried with wooden markers, and by 1869 these markers, just like those of the Confederate soldiers in their cemetery down the road, had disintegrated. Once the burials were complete, the present small, white stone markers replaced the old markers.

The design of the Marietta cemetery is, according to the United States Department of Veterans Affairs, the "most ornate and elaborate of its era." It covers almost twenty-three acres. The original section is laid out in a horseshoe shape around a flagpole, row upon row of small white stones. Most of the graves do not have names, marked only as "Unknown," with the name of the division the soldier marched with listed, if that. Illinois, Wisconsin and Ohio are heavily represented, so if these spirits do linger, they are far from home. The sight of the endless rows stretching on cannot help but affect any sensitive soul. Because they are laid out so neatly, they in some way seem to point out the futility of war and the waste of so many lives even more than the Confederate Cemetery nearby. More than 17,000 veterans are buried in Marietta National Cemetery, and of those, 10,731 were killed during the Civil War.

Veterans of World War I, World War II, Korea and Vietnam also are buried in the cemetery, which has been closed to new burials since 1998. It may be that the Union soldiers are not the only boys and men in uniform whose spirits may still strive to fight for their country behind the walls of Marietta National Cemetery.

The Witch's Graveyard

In the first place, there is no reason whatsoever to assume that a witch was ever buried in the Witch's Graveyard. That name

appears to be the invention of teenagers out for a good scare. There is a grave here that is surrounded by an iron fence, and someone, sometime, decided that the fence was there to keep the witch in her grave or some such nonsense. The grave actually appears to be that of a child, and the parents no doubt put the fence there to protect the grave, not to keep any spirit in or out.

The graveyard is on private property and it is heavily patrolled. Also, it is extremely dangerous to go there at night, as it is a notorious place for drug deals. There is no reason to ever go here at night alone or without specific permission to do so. I repeat, do *not* go there at night alone or without permission. You will be in danger from the living who gather there for illegal intent, as well as from the police, who *will* arrest you for trespassing. In addition, the gate is locked day and night, and even though trespassers have torn holes in the fence, it is unethical for anyone to enter this cemetery without permission.

However, there is no question that this cemetery has some paranormal activity. It does appear to be haunted, and there is reason to believe that the spirit or spirits who linger here are not all pleasant or happy ones.

Some of the most common phenomena experienced here are fogs and mists that appear only in this area and nowhere in the surrounding area, even on clear nights and even in the daytime; sudden drops in temperature, even just from one side of the fence to the other; the sounds of knocking from underground; and the sound of pounding drums. Thermometers have registered temperature drops of fifteen degrees from one side of the gate to the other. On a recent visit, I could feel the difference in temperature just sticking my hand through the fence. While most cemeteries feel peaceful to me, this is one of two in Marietta that make me uneasy.

Other reports include feelings of nausea and intense fear. Camera batteries, even new ones, often drain. Sudden mists appear from nowhere, and many have been caught on tape. Many people have captured EVPs of shrieks, moans, maniacal laughter and unintelligible speech.

No specific stories that can be verified offer any explanation of who or what is the cause of the unfriendly, or at any rate uncomfortable, activity in this graveyard, but the pounding of the drums may be remnants of the Native Americans who once

The so-called Witch's Graveyard. *Rhetta Akamatsu.*

roamed the area, and there was a fierce battle in the area that left trenches still visible on the hillsides almost a century and a half later. The entire area where the graveyard is located is full of stories of ghost sightings and contains several other haunted places that are discussed in this book. (It is my intent to keep the description of the location vague to discourage those who might go to the cemetery without permission.)

The Devil's Turnaround

The so-called Devil's Turnaround is an old cemetery in Marietta associated with a black Baptist church that was one of the first in the city, established in the 1800s. Some of the graves back in the wooded area date to the 1860s, while in the more modern part, there are graves as recent as 2006. The nickname derived from its reputation for unexplainable activity and the fact that the older graves are arranged in a semicircle. I am deliberately withholding the name of the church and the real name of the graveyard as I do not want to contribute to the bad behavior of a few that has caused legitimate paranormal investigators and those who want to respectfully visit to be denied permission more often than not.

Although the church with which the graveyard is associated was founded in the 1880s as one of Cobb County's earliest African American churches, it is hard to say how far the graves go back in the wooded area, as many of them are nearly entirely underground now and some are unreadable. Even more recent graves from the 1960s and '70s to the present have been disgracefully vandalized, scratched up or painted on. It is *heavily* posted and constantly patrolled because of the disgraceful vandalism that has taken place on the spot by thrill seekers and those people who call themselves "ghost hunters" when all they are is a disgrace to the very idea of paranormal investigation. Real paranormal investigators act in a professional manner and would never treat a grave with disrespect.

While it is unfortunate that the cemetery has been in disrepair since the 1990s, is threatened by neglect and has been allowed to become overgrown, except for the very newest part near the road, that does not justify vandalism and so-called "cult" activity among these graves, especially the older ones, which are already in disrepair back in the wooded area of the cemetery. Just because graves have not been kept up does not mean that they are not the resting places of other human beings and deserving of respect. On a recent visit, we witnessed big holes in the earth where bodies had literally been dug up! We also found a small snake with its head cut off and pentagrams crudely scratched into stones. Not too long ago, a dead dog was found buried in a shallow grave.

The Devil's Turnaround, so nicknamed for the original semicircular shape of the layout. *Crystal Pinson.*

No wonder there appears to be an angry spirit here. Any spirit forced to witness what has been done by the living in this graveyard would have a right to be angry. According to the *Marietta Daily Journal Online*, some police officers have recently begun cleaning up the cemetery, which does not seem to be owned by anyone at present. The most recent owner the newspaper could identify is dead. The officers have not ventured to the older graves yet but have concentrated on the newer section.

Some groups have asked for and received permission to investigate over the years, and they have recorded legitimate paranormal activity in this graveyard—some of it unfriendly and possibly dangerous. Although many of the reports are false, others are true and difficult to explain.

Among the urban legends about Devil's Turnaround is one that claims that a church, with all of its congregants in it, was burned on the property; there has, in fact, never been a church on the property. Other legends include tales that people were hanged on the property. This has also never happened as far as any records show.

However, there does appear to be a malevolent or angry spirit in this graveyard that makes its presence known in various ways.

A respectable paranormal investigation group in Marietta reported catching a number of EVPs in the cemetery, including one that seems to say, "I think I'll kick you." This EVP is posted online, and the voice sounds amused, as though this may have been a joke, but is quite clear.

Large objects that were brought here and placed on the ground have been hurled through the air. People hear howling, screaming and wailing at times. Many people report unexplained bruises, scratches and what look like bites after visiting the cemetery. There are, of course, branches, vines and brambles in the woods, but it is difficult to get bruised or scratched without feeling anything or to get caught on a bramble without having to disentangle yourself.

Patrick Burns, formerly of TruTV's *Haunting Evidence* and the founder and leader of Atlanta's Ghost Hounds Paranormal Investigation Group, recounted his first paranormal investigation at Devil's Turnaround at a recent Ghost Hounds meeting and gave me permission to share it in this book:

Broken stones and sunken graves add to the desolate feel of the older sections of Devil's Turnaround. *Rhetta Akamatsu.*

There was nothing happening in that cemetery. It felt really peaceful and serene, so much so that at one point I wandered back to a more remote part of the cemetery by myself. We rarely wander off alone during an investigation, but I felt perfectly safe. It was interesting to look at the old graves, but I didn't feel anything paranormal at all. We caught no EVPs, and no unusual EMF readings (electromagnetic field readings. High electromagnetic fields are believed by some investigators to indicate the presence of paranormal entities if there is no logical explanation for them.)

Later that night, I was at home getting ready for bed. I took off my shirt and when I pulled my arm out of the sleeve, I realized that I had a deep scratch running down my arm from my shoulder to my elbow. I had another across my chest, and another crossing that one. They weren't just lines, but actual scratches. The obvious first thought would be that I ran into brambles or thorns of some kind, but if I had, and it made scratches like that through my shirt, I would surely have known I did it. I didn't run into deep brush or brambles at all.

This sort of story emerges from Devil's Turnaround all the time. Many people have reported finding scratches on their bodies after visits, scratches they never felt at the time. Others have felt themselves lifted off the ground or had objects thrown at them by unseen hands. Some have found what looked like teeth marks or angry bruises on their bodies. None of them felt or noticed anything during their visits, some of which happened in the daytime, when they would surely have noticed anything capable of making such marks.

It is possible that the feeling of being lifted from the ground could occur from the unevenness of the ground and stumbling over pinecones and stones in some cases, but experienced investigators know to account for that sort of thing.

As for objects being thrown, some people have claimed that this is the result of people stepping on pine cones and loose stones in the dark. However, heavy objects that have been brought to the cemetery deliberately by investigators have also been reliably reported to have been thrown.

Some people claim that the unfriendly behavior in the cemetery becomes worse toward anyone wearing crosses or carrying rosaries or other religious items. In a recent talk at the Ghostock 7

paranormal convention in Salem, Massachusetts, Father Andrew Calder, who is an Episcopal priest and a demonologist who has appeared on a number of televised investigations, did state that some malevolent entities do react negatively to the presence of religious articles, but I am not aware of any experiments done by paranormal investigation groups who have problems with this at the Devil's Turnaround location. One investigator did deliberately go in wearing a large cross and carrying rosary beads and nothing happened to her.

Once again, the cemetery is posted and the police do patrol it. If you trespass in this cemetery at night, you are in danger of being arrested. You may also be in danger of inciting the wrath of an angry entity, and that is not something that should be done for fun. No matter what your beliefs concerning the paranormal, there is never any good reason to be in any cemetery or other allegedly haunted location after dark without permission. Don't do it.

Holly Springs Cemetery

Holly Springs Cemetery in the East Cobb section of Marietta is located in front of what is now Emerson Unitarian Universalist Church, which owns the building that for many years housed generations of Methodists. About six hundred people are buried in the small churchyard.

Most of the stories of ghostly activity in this cemetery have been lost as the older members have passed on. Enough remain, however, to be intriguing.

Holly Springs Methodist Church was formed in 1825. The members constructed a crude log cabin as a meeting place, with neither windows nor floors. It was cold in the winter and hot in the summer, and yet the church prospered and grew until 1860, often averaging as many as fifty people at a meeting.

Into the small cemetery went the first graves, with the first one, in 1841, being that of Private Peter Groover, who had fought in the Revolutionary War.

Many years later, another grave was added, not exactly in the boundaries of the churchyard but right outside it, between what is now the driveway and the cemetery sign. This gave belonged to one Pink L. Doss, known as "Pinky," who was either the son or grandson of slaves and who worked for the Groover family. Pinky was well liked in the community, and when he died, many people wanted to bury him in the cemetery, while many others did not. This was the South in the 1930s, and racism was a way of life. It was considered unseemly to bury black people and white people in the same cemetery. So they compromised, and Pink Doss is buried *almost* in the cemetery. It is these two graves that are rumored to have had some ghost sightings connected to them over the years.

In addition to Peter Groover's grave, fifty-eight other stones here date from the 1800s.

According to a history posted on the Internet that was obtained from Pitts Theology Library at Emory University by the Holly Springs Memorial Association and was marked with a handwritten date of 1972, Holly Springs Methodist Church received a great blow when, in 1860, "every male member between the ages of 14 and 66 joined the Confederate Army." It sustained yet another horrible hit in 1864, when "Sherman and his vagabonds" burned the cabin to the ground.

In 1867, the members rebuilt with another simple structure, this time with windows and a floor. Despite the small size and rural nature of the community, membership at that time was usually around one hundred, and the church was prosperous enough that another building was erected in 1905 that was essentially the same in appearance as the church now occupied by the Emerson Unitarian Universalist congregation.

Between 1900 and 1905, the church prospered, with Circuit Riders holding revivals so large that people crowded the space outside the building, as well as inside. There were all-day singings and dinners on the ground, and the church was a social, as well as a religious, center. After 1925, however, attendance dwindled, and the church building was sold in 1987 to the Emerson Unitarian Universalist Fellowship. The Unitarian community today also seeks to be a spiritual and social center for the more liberal religious community and seems to live in peace with the legacy of those many generations of Methodists.

The small cemetery is beautiful and peaceful these days, and most of the residents seem to be at rest. But who is to say that the soldier and the sole black man do not still meet, on occasion, on moonlit nights to walk among the stones and converse about the changes that they have seen, as they have been reported to do in the past? (Charles Switzer of the Holly Springs Memorial Association is seeking descendants of those who may be buried in the cemetery and would appreciate it if anyone with an interest in the cemetery would contact him at (770) 436.2679.)

HAUNTED BRIDGES

Bridges are often associated with ghosts. This may be, in part, because bridges, suspended in the air as they are, are intrinsically creepy and highly symbolic of the bridge between life and death so that our minds make that connection for us. It may also be in part because bridges are often the sites of accidental death, suicide and even violent acts.

In the same general area as the so-called Witch's Graveyard are two bridges that have stories of paranormal activity associated with them. One of these bridges is Cochran Bridge, also known locally as "Crybaby Bridge."

There are Crybaby Bridges all over the country, and the stories are very similar. It is most likely that these stories are merely urban legend. Georgia, in fact, has a much better-known Crybaby Bridge in Columbus.

However, there are many people who claim to have had unusual experiences on this bridge. According to local legend, if you stop your car on the bridge, not only will you hear crying coming from under the bridge and feel your car being pushed backward and forward, but also small, wet handprints will form on your car windows and hood. Most of these legends stem from the time when the bridge was less busy; now it is part of the very popular Silver Comet Trail, where bikers and joggers abound, and traffic is heavy. Stopping on the bridge is frowned upon by the authorities, night and day, not to mention extremely dangerous.

Both this bridge and the Concord Covered Bridge are in a very active area where there have been many reported sightings and where there are several places that have long been held to be haunted.

Certainly the Concord Covered Bridge may have more of an obvious historical claim to real activity. For one thing, it is very near one of the haunted cemeteries discussed in this book and therefore may have some of the same spirits around it as those that cause activity around the graveyard. For another, it is located at the site of the Civil War Battle of Ruff's Mill, and a few remnants of that mill still remain. This battle took place immediately after the Battle of Kennesaw Mountain. The bridge did survive the battle, but it is not clear whether most of it was subsequently destroyed or only structurally damaged before the end of the war.

The original Concord Bridge was built in 1848. The present Concord Bridge was built in 1872 and fortified and renovated in 1983, but some of the abutments are believed to date from the original 1848 bridge. The original bridge served a small but vibrant community that included a woolen mill, a gristmill, a sawmill, houses, churches and schools. This bridge and the woolen mill (Ruff's Mill) were burned during the Battle of Ruff's Mill, which took place to the west of the bridge, and the railroad that ran through the area was destroyed at that time as well. The trenches from that battle can still be seen in the hills. The bridge was rebuilt in 1872, but the railroad and Ruff's Mill were not replaced. In 1983, the bridge was reinforced, and a new electrical light system was installed.

The present Concord Bridge is 132 feet long and 16 feet wide. The most common occurrence here concerns the lighting. Many times, people have started across the bridge, only to have all the lights go out when they reach the middle and come back on when they reach the end. I personally have experienced this phenomenon more than once. It might be a fault of the lighting system, but the lights never seem to go off at the beginning or the end of the trip across the bridge, only at the middle. Other people have photographed red mists on the bridge and other strange fogs as well.

Whether there is a logical explanation for the strange behavior of the lights and the appearance of mists at Concord Bridge, and whether all of the stories about Cochran Bridge are urban myth or not, it is certainly interesting that one area of Cobb County has attracted so many legends and stories of paranormal activity: a haunted cemetery

and two allegedly haunted bridges a few miles apart, at least one allegedly haunted warehouse and a story of a phantom car that appears near a wall surrounding a house close to Cochran Bridge and, legend says, will follow you if you pass the house and stop briefly near the wall late at night.

SHADES OF THE SQUARE

Marietta Square is full of buildings that were built soon after the Civil War, from the late 1800s to the early 1900s. Many of these buildings have been home to a variety of businesses for over one hundred years. Today, a great many of them are antique shops, filled with items that have been gathered from the past and brought here to this place where the very air seems filled with the past, as well as the present. It is no wonder, then, that some of these buildings still seem to have lingering spirits or traces of the past.

The Three Bears Café

At this writing, the Three Bears Café has fallen victim to the economic times and closed, but the building it inhabited has long been reported to be haunted. Before it was the Three Bears Café, the building was first the Cobb Theatre and then a nightclub called Charades, followed by a heavy metal music venue called the Darkside. It is from one of these earlier incarnations that the haunting seems to stem.

In an article in the *Marietta Daily Journal* in October 2007 entitled "Local Haunts," the manager of the Three Bears Café recounted an

Left: The interior of the Three Bears building, through the glass door. *Rhetta Akamatsu.*

Below: The former Three Bears Café building, which closed during the writing of this book. *Takesi Akamatsu.*

incident when she was carrying food from the basement kitchen to the bar upstairs:

> *It was just another early evening at Three Bears Café, and manager Malia Hennies was carrying food upstairs from a basement kitchen. The staircase light was burnt out, it was dark and when she reached the top of the platform, she heard heavy footsteps following her. She turned around to thank the cook for helping her—but no one was there.*
>
> *"It was very clear that someone was walking up the stairs. I got goose bumps and a cold chill. It was definitely creepy," said Hennies. "I believe in ghosts and perhaps another realm…but it doesn't frighten me like that. It's almost playful."*

Customers often reported seeing a dark figure in the wings to the right of the stage area in the bar, especially during musical performances.

According to Joni Goodin of the Ghosts of Marietta tour, the ghost is believed to be a woman and to prefer the second floor of the building.

A former employee, who is male, told me the following story:

> *When I worked at the Three Bears, only the front part and the pub were open for business, and the middle part was not used. Sometimes, if an employee worked a double shift or was really short on money, we would be allowed to sleep in that area for a night. I was sleeping in there one night after pulling a double shift. It was cold, and I had my coat pulled over me like a blanket. I kept pulling it up over my head, but all night, it felt as though someone or something was grabbing it and pulling it off of me. No matter how I tried to anchor it with my legs and arms, it would be pulled away. I didn't know about the ghost then, but it sure explains a lot.*

Several people have mentioned that there also seemed to be something strange about the upstairs bathroom. Even former customers have casually mentioned that something seemed not quite right about that bathroom, although there is no history or background story to suggest why that might be.

"It was a perfect bathroom," one said. "It had pristine, new appliances, and it looked great. But nobody ever used it. In fact, we never went up those stairs."

"We all avoided the second floor whenever we could," my informant told me. "Except for the manager, nobody went up there unless they had to."

Will the next business to occupy this historical building inherit the ghost? Only time will tell.

JOHNNIE MACCRACKEN'S CELTIC PUB

Johnnie MacCracken's Celtic Pub is an extremely popular hangout in Marietta, with great food, plentiful drink, frequent live music, a very loyal following and a ghost that appears to predate the club by at least one hundred years.

When owner Gary Leake opened Johnnie MacCracken's in 2002, he chose the building that used to house the oldest standing fire department in Marietta and one of the oldest in Georgia. The fire department was established as Marietta Engine Company #1 after a disastrous fire started in the basement of Denmeade's Department Store in 1854. By the time the Atlanta Fire Department got to the blaze, most of the square had been destroyed, and it was obvious that Marietta needed a department of its own.

Johnnie MacCracken's Celtic Pub, a fun place to go, has a ghost that is regularly seen. *Rhetta Akamatsu.*

This area at Johnnie MacCracken's is where the ghost is often seen. *Rhetta Akamatsu.*

It was a great day when Marietta got its first steam engine, a horse-drawn Silby steamer nicknamed "the Aurora" by the citizens, which can still be seen at the Marietta Fire Department Museum on Hayes Street. Men and women lined the streets and cheered. The Aurora served Marietta until it was replaced with the motorized American LaFrance in 1921, one of the first motor-driven fire engines in North Georgia.

Later, when more equipment was required and the space became inadequate, the fire department moved to a larger space, and the building became Session's Savings and Loan about 1917. There are still two working bank vaults to the left of the bar that are used for storing beer.

It is in the downstairs area of the bar that the spirit is seen most often. The original reports came from employees working alone late at night.

The ghost appears to be a young man in period dress, and, according to Joni Goodin of the Ghosts of Marietta Tour, he prefers the company of women.

The stairs at Johnnie MacCracken's, where you may encounter its resident ghost. *Rhetta Akamatsu.*

Is he one of the firemen from the early days of the building, or is he from one of the later incarnations as a bank or as a business?

No one knows for sure. Certainly, he is not Johnnie MacCracken himself. The pub's website explains that the pub was named in honor of a group of Scottish firemen who died in a Cardage factory fire in Glasgow, Scotland, and that Johnnie MacCracken is the pub mascot, standing for the Celtic values of truth, honor and justice.

Whoever the ghost is, perhaps he enjoys the good music and great company he finds at the pub, as you certainly will.

THE THEATRE IN THE SQUARE

Theatres often seem to attract paranormal activity. Maybe actors and people attracted to theatre are more sensitive and more likely to see

and acknowledge ghosts and the supernatural than others, but many theatres do appear to be haunted, often by the spirits of actors or directors. That is not the nature of the paranormal activity alleged to take place at the Theatre in the Square in Marietta, however.

In the case of the Theatre in the Square, it is not a person but a location that seems to sometimes surface from the past, offering a glimpse into a time that is long gone.

The Theatre on the Square first opened in 1982, in a former storage building behind the old Marietta Train Depot. As it grew, it moved to a much more convenient and less noisy location on the square. It is now housed in what used to be an apothecary at the turn of the century. The theatre is a hub of cultural life in the city, offering a great variety of theatrical and musical entertainment for thousands of loyal subscribers.

But sometimes, the building seems to have trouble remembering what it is supposed to be.

A former employee, who used to work the lights at the Theatre in the Square, claims that new employees were often initiated in the following way: The new employee was positioned in the center of the auditorium, facing the stage. All of the lights were turned out. Slowly,

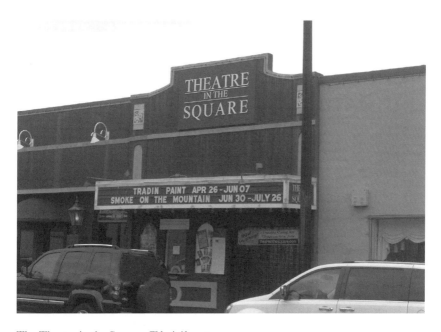

The Theatre in the Square. *Takesi Akamatsu.*

as the new person's eyes adjusted to the dark, the interior of the old apothecary building emerged, complete with shelves full of jewel-colored bottles, scales, old-fashioned medical equipment, barrels and the old-time soda fountain.

This kind of scene is generally considered to be residual, a kind of "hologram" or movie stamped on the atmosphere of a building or place, and has no intelligence or meaning behind it. But it certainly must have generated interesting responses from unsuspecting new-hires or volunteers. Another theory from quantum physics claims that time is not really linear but exists in parallel layers—past, present and future bordering one another. Perhaps, in some places like the Theatre in the Square, there may be peepholes through the layers of time, occasionally letting us catch a glimpse of what has already been, if not what is to be. There have been other instances, in other places, where people were walking along the street when suddenly the scene was replaced by an earlier one, with carriages instead of cars and homes instead of office buildings, or where a busy office building was suddenly momentarily filled with people sitting at old-fashioned desks, wearing old-fashioned clothes.

The Strand Theatre

Another example of theatres attracting paranormal activity is the Strand Theatre, Marietta's most well-known movie palace, which recently reopened after years of being used for various club ventures and retail establishments and then stood vacant for some time.

The Strand was opened by the Manning-Winks Theatre Company in 1935. It incorporated the latest modern innovations, including air-conditioning, an acoustic sound system and a fireproof projection room, important in the days of flammable celluloid film. The theatre had seating for one thousand people and cost $150,000, a fortune in the midst of the Depression.

The Strand building was built on the site of the Najjar Department Store, which was the source of a fire started by a faulty heater that destroyed most of the northeast part of the square during a fierce storm on Halloween morning in 1932. (An interesting side note is

that there was to be another fire on the square on Halloween, exactly thirty-one years later.)

The first movie shown in the theatre on September 4, 1935, was *Top Hat*, with Fred Astaire and Ginger Rogers. The Strand continued to entertain generations of Marietta citizens until 1976, when movie sales dwindled and Herbert Goldstein bought the property and turned it into retail space. Actress Joanne Woodward has attributed her career to the years she spent watching movies at the Strand Theatre in downtown Marietta. She wrote to city officials in 1989: "My entire childhood was spent in that theater and it's certainly one of the major reasons I became an actress."

Ms. Woodward was not the only one to spend her childhood at the Strand. Generations enjoyed double features, Saturday horror matinees with real "monsters" that would wander through the audience scaring people and handing out candy and Saturday evening dates, sitting in the balcony paying more attention to each other than the movie.

There were some colorful characters who worked at the Strand from time to time, including one former manager named Tiny, who had been a Marietta policeman before he was fired for shooting several black people without provocation. Perhaps he may be the cause of some of the later activity.

Between 1982 and 2002, the building was used for a number of businesses, including a teen club, a bar, a church and a live music venue called Club Chaos. During the period when some renovations were being made on the building for Club Chaos, there were tales of tools and equipment going missing, and one club employee, working late at night, swore that he often heard voices and footsteps in the lobby, only to find no one there upon investigation.

Once Club Chaos opened, musicians often complained that their equipment had been moved or was missing, and one musician claimed to have encountered a full-body apparition in his dressing room. Other musicians and patrons claimed to see black, shadowy figures in the balcony during rehearsals and performances.

None of the ventures in the Strand building lasted very long, a fact to be attributed not to the paranormal but mainly to parking problems.

In 2002, the building became vacant and stayed that way. It began to deteriorate while community leaders debated what to do about it.

Finally, in 2003, a nonprofit organization was formed—the Friends of the Strand—and fundraising efforts began to acquire the $5 million to completely renovate the building and provide initial start-up costs. It took five years, but on December 5, 2008, the completely renovated Strand, which was entirely gutted and rebuilt with an orchestra pit, new rooftop terrace and two new reception rooms, opened to the public with a viewing of Atlanta Lyric Theatre's *Beauty and the Beast*. Today, the Earl Smith Strand, as it is now called, is providing a variety of programming, from live theatre to music to movies, for Marietta citizens once again.

Renovation often stirs up paranormal activity. If there were incidents during the renovation, nobody is talking about them. But it will be interesting to see if the ghosts of the Strand will manifest now that the theatre is once again in regular use or if the extreme changes have finally exorcised them from the building.

Other Stories from the Square

There is an alley between Atlanta Street and Winters Street on the square. This area is lined with small stores and businesses. One of these businesses is now the Marietta Cigar Shop. At other times, this building has been a clothing store, the Marietta Sherriff's Office and a movie theatre.

When it was a movie theatre, there was a door that led from the theatre into the alley. Legend has it that one day a young man came in, sat down, watched a movie and then exited through that door into the alley and shot himself in the head, dying instantly. They say that you can still see the scar from the bullet in the brick if you look closely. "They" also say that you can encounter the ghost of the young man in the alley from time to time.

A bizarre tale is told that sometimes a man who "appears to be decaying" can be seen crawling out of a manhole on the square. My feeling is that this may be an urban explorer who is being viewed by a few people enjoying too many drinks at one of the square's outdoor tables.

Left: The Cigar Store, formerly a movie theatre, possibly the Strand before it moved across the square. *Rhetta Akamatsu.*

Below: The alley where you may sometimes encounter a young, male ghost. *Rhetta Akamatsu.*

Of course, Marietta is not without its own phantom hitchhiker, as well. Every town in America seems to have some version of this story. According to the Shadowlands website, a woman sometimes asks for a ride home from Marietta Square, only to disappear when you reach the graveyard, as you would expect.

As mentioned earlier, there are also some strange reports floating around the Internet of people with human bodies and the heads of beasts, or vice versa. I have been inclined to dismiss these stories, but it is possible that they may be costumed revelers who were

injured or killed in the 1963 gas explosion that took place during a Halloween celebration on the square or in the earlier Halloween explosion in 1932.

The square is old and full of history. It is also full of antique shops. Some of the shop owners have their own stories to tell, which are shared by Joni Goodin on the Ghosts of Marietta tour. I am sure that many legends of the square have not been told in this book and that many more will emerge as time goes by.

HAUNTED HOUSES AND BUILDINGS

The places where people live their lives and build their families, where they celebrate births and mourn deaths, are the places to which we would expect spirits to be attached. And indeed, in Marietta there are houses that seem to contain a former inhabitant or two, in less solid form. These were the homes of people who helped to build Marietta and who were deeply involved in the political and social development of the city. In addition, this section includes the Brumby Chair Factory, which was the home of a major family-owned enterprise and has now become Brumby Lofts, an excellent blending of the past and the present that may have an extra resident or two who are not included on the books.

THE 1848 HOUSE

The 1848 House was built by Marietta's first mayor, John Glover, a former Charleston, South Carolina planter who had moved to Marietta in 1847. Glover is the man who donated the property for the park that now bears his name—Glover Park—in the middle of Marietta Square, still the center of Marietta social life today. It was his wife who donated the property for the Confederate Graveyard next to the City Cemetery after the Civil War.

The 1848 House, formerly a plantation house, then a restaurant and now a private residence. *Postcard.*

Originally, the house was a true plantation house, set on thirty thousand acres of land and surrounded by many outbuildings. Glover built a tannery on the property at the same time, which was burned during the Civil War. The location was then known as Bushy Park. The house contains seventeen rooms, hard pine floors and hand-hewn beams, and for years its appearance has continued to reflect the lifestyle of a prosperous Marietta citizen of the pre-war 1800s.

In 1851, John Glover left the 1848 House and built a house on Whitlock Avenue near Marietta Square at the urging of his wife, Julia, who thought that Bushy Park was too far away from the social life of the town. That house suffered more in the war than the 1848 House did, since it was set on fire and partially burned, and the soldiers stationed there used the parlor to stable their horses and stole everything valuable they could find, including the family silver and portraits.

By the time the Civil War broke out, Bushy Park had been sold to William King, the son of Roswell King, for whom Roswell, Georgia, is named. William King recorded in his diary that a skirmish took place on the grounds on July 3, 1864, during the Atlanta Campaign.

A bullet from that skirmish can still be seen embedded in a wooden door. Later, the building, like many large buildings in Marietta and throughout Georgia, was used as a temporary hospital. The Scarlet Room, in particular, which was used as an operating room and was no doubt the scene of much suffering and death, seems to have activity resulting from that time.

During the war, Mr. King also invited Union officers to use the house as a headquarters, not because he sympathized with the Yankee cause but because he knew that if the officers were using the building it would be protected. Former owner Bill Dunaway told the History Channel's *Haunted History* that at least up until the 1930s, hoof prints could be seen in the wooden floors of the halls because the soldiers insisted on bringing the horses inside at night so they would not be stolen.

In total, the house has had twenty-three owners to the present and has been both a residence and a well-regarded restaurant. One of its former owners was Robert Garrison, president of the Arrow Shirt Company. The 1848 House's most recent claim to fame began in 1992, when Bill Dunaway, a pharmacist who owned a chain of drugstores, decided to sell them to Eckerd's and poured the money into turning the 1848 House into a fine, upscale restaurant. Mr. Dunaway began serving as mayor of Marietta during the 1990s. He gave many interviews and spoke very openly about the paranormal activity in the house while he owned it. He was quoted as saying that he was "not sure if there were actually ghosts, but he did not intend to stay in the house overnight by himself and become a believer."

As soon as the restaurant was open, many of the classic signs of a haunting began to occur. Lights flickered on and off in the upstairs hallway for no reason, doors opened and closed on their own and a stereo that was set to play soothing music suddenly blared rock and roll, changing the station when no one was near it.

Many people have reported experiencing unexplained phenomena at the 1848 House, both before and during its restaurant days. Female employees were often teased and flirted with by some unseen entity. This male figure, or another male figure, has also been seen in the house by employees and guests.

A gunshot, believed to be an echo from the Civil War skirmish, has often been heard from the steps. Many diners have seen the

chandelier shake in the Scarlet Room, and not just gently, but literally swaying back and forth as though someone were violently pushing it. The rocking chairs on the porch were known to rock by themselves, even on days when there was no breeze.

Ron Allen, who was chief executive of Delta Airlines at the time, rented the 1848 House as Delta's hospitality headquarters during the Atlanta Olympics. An interview that Allen gave the *Atlanta Journal and Constitution* about the closing of the restaurant was quoted on the website "Civil War Talk": "Drinking mint juleps on the porch is a great Southern tradition, and you can do that there. It has some great stories, I think there may even be some ghosts in those old closets."

Blogger Eddie Hunter, who writes the popular blog "Chicken Fat," tells the following story in an account of a visit he and his wife paid to the 1848 House:

> *My father was born in 1913. When he was a teenager, the 1848 House was vacant for a brief time. It was believed to be haunted then also.*
>
> *One night a group of boys dared Daddy to spend the night. He made an attempt to, but during the night he felt something pulling at his hair. He ran out. The next day he and the boys went back to investigate. Where he reclined were cobwebs behind him. He believed the cobwebs pulled his hair.*

It may or may not have been the cobwebs, but this story illustrates that the 1848 House has had stories of ghosts attributed to it for a very long time.

In what is probably the most haunted room in the restaurant, the Scarlet Room, employees standing outside the building once reported seeing a woman dressed like a pre–Civil War belle through a window, moving about the empty room.

This woman, or another spirit, was also seen by guests who were sitting in a glassed-in area where they could see into a window in the older part of the house. They heard a train whistle, and suddenly a woman appeared in the window, wearing a long white dress. When the whistle faded, she disappeared. As soon as the whistle came again, she reappeared, only to fade away as the train moved on.

Poltergeist activity occurred regularly while the house was a restaurant. On one occasion, a very surprised couple who were dining in the Scarlet Room once had a centerpiece rise up from the table and float in the air in front of their faces.

Former employee Dot Dunaway recalled for *Haunted History* another incident involving a flower arrangement. She said that she had arranged the flowers earlier in the day in a large vase and sat them on a sideboard, ready for a private party that evening. Later, when the party had just ended and the guests had departed, Ms. Dunaway was standing with her back to the arrangement, speaking to a friend. Her friend watched in awe as the vase rose into the air as though someone had lifted it, hovered and then fell, spilling flowers everywhere. Seeing her friend's face pale, Mrs. Dunaway asked, "What's the matter?" Her friend said, "Something just lifted the vase from the sideboard and threw it on the floor." When she turned to look, sure enough the flowers and the vase were spilled across the floor.

Clocks in the house sometimes run backward as well, only to show the correct time again moments later. This occurrence was so common that Nancy Roberts entitled her chapter about the house in *Georgia Ghosts*, "Where Time Runs Backwards."

Among the groups that have investigated the house is the Georgia Haunt Hunt Team, which investigated with cameramen from WSB-TV and a reporter from *Athens Flagpole Magazine* and caught many light anomalies in their photos, including in the attic and in the old outside kitchen, which is separate from the house.

Certainly, the 1848 House remains one of Marietta's most famous haunted locations. The 1848 House Restaurant was beloved and well-regarded, but it closed in 1996. The house is still there, however, although it is now surrounded by a housing development of upscale condominiums and the gate is generally closed and locked.

Its loss as a restaurant and center of southern hospitality is regrettable. But the memories and the stories remain, and if the lady in the window of the 1848 House still appears when the train whistle blows, perhaps new stories will yet arise from the condo dwellers who live around the house.

The Chaney-Newcomer House

The Chaney-Newcomer House, on the corner of Bankstone and Powder Springs Roads in Marietta, was built about 1856 by Andrew Jackson Chaney.

Mr. Chaney and his family lived in the house, but they also ran it as a sort of inn, allowing travelers on the original Tennessee Wagon Road, which ran from Tennessee to Alabama and wound right through the front yard of the house, to stay overnight. He also allowed cattle drovers to camp overnight on the property around the house. It must have been quite a scene, to see the settlers with their wagons, horses and cattle, the cattle milling around, churning up the dirt or the mud of the yard, while those who could afford it enjoyed the hospitality of the house and the Chaney family.

The house maintains the original flooring and the very unusual wood ceilings downstairs. It is one of very few historical houses in Georgia that have both stone masonry and wood on the exterior. It also has the almost unheard-of feature of having small closets in most of the rooms. Most southern houses did not have closets in those days. People kept their clothes in chests or chifforobes.

In late 1864, the house became the headquarters of General Schofield, and scores of Union troops camped in the house and all over the property. It was also pressed into service as a hospital during the worst of the fighting along Powder Springs Road and throughout Marietta. This, and the fact that there was no actual battle on the property, allowed the house to survive the war when so few houses in Marietta did. General Sherman inspected the right wing of the Kennesaw Line at the house before the Battle of Kennesaw Mountain.

Upstairs, there is an unfinished room in which you can see the peg and board construction of the house. The story is that the Chaney family lost a child during the construction of the house and did not have the heart to finish the room. Experts on southern architecture claim that it is not at all uncommon to see antebellum houses with unfinished rooms, often because they were meant for family members who died before their completion. The anger and grief over this loss offer one possible explanation for the ghost that is seen here.

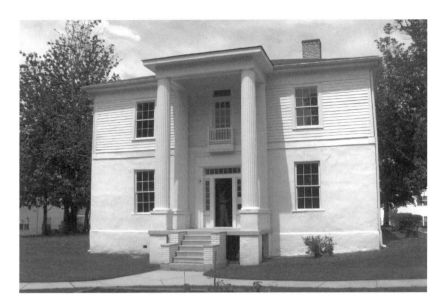

The Chaney-Newcomer House. *Rhetta Akamatsu.*

After Andrew Jackson Chaney died in 1886, the property was rented out and at times stood empty and was allowed to deteriorate, until, in 1953, Mr. Kenneth Newcomer purchased it. Mr. Newcomer was a native of Pennsylvania and a private pilot who had trained British pilots during World War II. He worked at Bell Aircraft and Boeing and retired from Lockheed in 1972. He was also an amateur historian who changed very little in the house, other than adding electricity and a small modern kitchen. Photos taken at the time seem to indicate that Mr. Newcomer took great pride in the history of the house, and he did a great deal of research about it. Some people feel it may be his ghost that haunts the upper part of the house, shaking his fist out of the window at the development around it.

After Newcomer's death at age eighty-nine in 1999, a development company bought it and built an assisted-living facility on the grounds. As part of the arrangement, the company stabilized the house and donated it to the Cobb Preservation Foundation, which is presently seeking a buyer for the house. If anyone has an interest in a haunted antebellum home, this house is a real opportunity for there is reason to believe that either Mr. Chaney, Mr. Newcomer or some other male resident has not left the now-vacant home.

Many people have reported seeing the figure of an elderly man standing at an upstairs window that faces the road, looking down. Sometimes he appears to be shaking his fist and seems angry. It is impossible to say if this figure is residual and reliving an angry event from the past, perhaps frustration over the cruel suffering of the soldiers who were brought there, wounded or dying, or anger and frustration over the course of the war and the state of the town. Perhaps it is Schofield himself, venting his fury at the difficulties of the battle or the stubbornness of southern towns like Marietta. Perhaps it is Mr. Chaney or Mr. Newcomer, upset and alarmed at the condition of the property. Whatever the case, the sightings continue. In "Marietta Ghost Tales" at the Ghosts of America website, "Sarah" states, "I took a couple of friends with me and truly never expected to see anything, but I have seen him 4 different times now. It's very real."

The Chaney Newcomer House is a beautiful home and a real part of Marietta history. It is devoutly to be hoped that the Preservation Society can find a buyer to give it the care that it needs and perhaps bring peace to any spirits that inhabit the house.

The Brumby Chair Company/Brumby Lofts

Brumby rocking chairs are among the most famous and best-loved rockers ever made. They have been found on the front porches of homes, inns, hospitals and government buildings from the late 1800s to the mid-1900s. Countless babies have been rocked in Brumby rockers. Today, the original chairs are treasured as antiques. Chairs made by the same design are still being sold from a small space on Marietta Square, with a new Brumby generation in charge once again.

The distinctive rocking chairs were, for years, created by generations of the same family and by workers who also sometimes included grandfathers, fathers and sons working together at the Brumby Chair Company in Marietta. Today, the former Brumby factory has been converted to trendy and popular loft apartments, but there is good reason to believe that at least one Brumby family member or dedicated

factory worker is, or was, until recently, still hanging around from beyond the grave.

The first Brumby rocking chairs were made in 1875. James R. Brumby worked as a tanner before and during the Civil War, but the tannery, like most of Marietta, was burned to the ground in 1864 while James was serving in the Confederate militia. He tried to start another tannery, but that business failed, so he enlisted the aid of a former slave named Washington and began making barrels for the local flour mills.

When the mills started switching from barrels to sacks, Brumby had to think of another product. That's when he created the first Brumby rocking chair, using a lathe he bought at a court auction for twenty-five dollars and constructing the chair of hand-carved red oak, with a back and seat that were caned by hand.

The chair was a hit, so he continued to make others, forming a partnership with a friend, Major Henry Myers, and sending for his brother Thomas to come from Mississippi to join him in the business.

In 1878, the first Brumby Chair factory was built on Powder Springs Road. It burned down almost immediately, as so many buildings did in those days, and was rebuilt in time to begin operations in 1879. By 1884, the company was producing dining chairs, stools, office furniture, cribs and other furniture, in addition to the rocking chairs, but the rockers were the core of the business.

Three generations of the Brumby family owned and operated the business. James Brumby ran it until he retired in 1888. He lived a long life and died in 1934. When he retired, his brother Thomas took over the company and ran it for thirty-five years. Under his care, the company grew and prospered on the strength of the popularity of the distinctive Brumby rocker. Thomas Brumby also became mayor of Marietta for a time and the first president of the Marietta Electric Company.

In the 1930s, not only did the Depression have some effect on the business, but the family was also hit with a string of unfortunate deaths. James R. Brumby II died in 1933, in his forties. His brother, W.M. "Jack" Brumby, died in 1935, also still in his forties. Thomas Brumby Jr., who took over when his father retired in 1928, successfully kept the company afloat during the difficult '30s, but he died in 1938 at age fifty. It is this series of misfortunes that may have resulted in

The Brumby Lofts. *Takesi Akamatsu.*

the haunting activity that took place in the building at least until the late 1990s.

After the deaths, the Brumby widows asked Robert Brumby to return to Marietta to take over the leadership of the business because they did not feel that any of the younger Brumby offspring were old enough to take on the responsibility. Robert had been a successful lawyer in Louisiana before returning to take on the task.

Robert tried to keep the company going, but World War II proved to be one final obstacle too many. Many workers went to serve in the war, and others were lured away by the new Bell Bomber Plant. The company might have survived that, but the war also meant that there was no longer cane from Asia for the chair backs and seats. Robert and his brother Otis reluctantly sold the company to another manufacturer, and by the 1950s the Brumby rockers were no longer being produced.

In 1967, Frank and Carole Melson got a license to produce the Brumby rockers again, and in 1972 the first rockers since World War II were constructed. When Jimmy Carter became president, he

ordered five of the chairs for the White House. In 1991, when Carole Melson, then a widow, retired, Otis Brumby gained permission from his five remaining Brumby relatives to return the business to the family name and opened the Brumby Chair Company showroom on Marietta Square.

In the meantime, the original factory was used by a furniture company, then an aluminum company and later sat empty for a while before becoming office space in the 1990s. In 1995, the Winter Company completely renovated the building and turned it into loft apartments.

It was during the time that the building was in use as office space in the early 1990s that the first reports of something strange going on began to appear. Office workers heard strange noises, especially from the bathroom, which was in a completely isolated area off the common hall at the back of the building. People in the bathroom would often hear loud banging from the empty second stall. Workers also reported footsteps behind them or in empty hallways and reported a general feeling of being watched by unseen visitors.

I have been able to find no accounts of unusual occurrences in the building since it has been renovated and turned into lofts. Perhaps the changes and the introduction of so many people have caused the entity to no longer feel the need to watch the building. It is more likely, however, that noises such as footsteps are not being noticed because of so many living inhabitants, as some tenants complain online about their noisy neighbors.

Petersen's Florist

When I learned that Petersen's Florist, which is located in a historical house on Church Street in Marietta, has had paranormal activity and has been investigated and found to be haunted, I felt personally vindicated.

In 2003 and 2004, when my husband, my daughter and I were all working at the same local business, Lason, Inc., we used to drive home past Petersen's every night between 11:30 p.m. and 12:00

a.m. One night, my daughter looked up at a second-story window and clearly saw a figure standing there, which flickered and was gone. I did not see it that time, but the next night I looked and there she was. We returned in the daylight to make sure there was no cardboard cutout or other item in the window that we could have seen, but there was nothing. After that, one or both of us saw the figure many times. We were sure the place was haunted, but I could never find anything online or elsewhere about it.

However, every time we pass Petersen's (at least several times a week) I feel drawn to it, and I have told my husband many times that of all the houses in Marietta, that one feels to me the most haunted.

Then, very recently, I had the opportunity to talk to Lorenzo Cintron, who has owned the house and the florist business for about two and a half years. Mr. Cintron was very courteous and enthusiastic about his ghost. He confirmed that the house has definitely been active in the time he has been there and was pleased to hear from someone who had seen the ghost before he owned the business, as he said that some people claimed it never had a ghost until he got there. He and his staff have heard footsteps, have seen things fall in front of them and have heard noises. They have also caught fleeting glimpses of the ghost that is definitely a woman. They believe she is the daughter of the former owners of the home, who also owned the house next door. Mr. Cintron said that the two houses were one property at the time. The house was investigated by a very reputable local paranormal investigation team, and they did find evidence of paranormal activity.

Since the investigation, there has not been much sign of the ghost in Petersen's Florist, other than a few soft noises and the occasional light footfall or falling object, but the owner says that she should not be written off. He believes that she has simply moved to the other house, which, he says, has lovely period furniture and does not have so much of the appearance of a business. Perhaps when our lady spirit gets the urge to spend a day among beautiful flowers, she migrates back for a visit to that part of her old home.

The Root House

The Root House is not a mansion or a plantation house. It is a very homey example of a prosperous but solidly middle-class family's typical residence. It was built by William Root, who was born in Philadelphia in 1809. In 1836, he moved to Marietta from Augusta, Georgia, where he had worked with druggist William Kitchens, and opened the town's first drugstore, which quickly became a social center for the early settlers. He built Root House in 1845, after his marriage to Hannah Simpson, daughter of one of the first pioneer families in Marietta.

The house did not then sit in its present location at the corner of North Marietta and Polk Streets near Marietta Square. In fact, it has been moved twice since it was originally built. It originally set on the corner of Church and Lemon Streets, and in the late 1890s, it was rolled back on the lot and turned to face Lemon Street in order to make room for Marietta's first library, the Sarah Freeman Clarke Library. Then, in 1988, the house was scheduled for demolition, but thankfully the Cobb Landmark and Historical Society was able to save it by moving it to its present location at Denmead Street. Now, the house performs an invaluable service to the public as a house museum, with much of the original furniture and regular tours that offer a glimpse of how middle-class town life was lived in the mid-1800s.

Nine people occupied the Root House at one time, seven of whom I have identified: William Root, his wife Hannah, Hannah's mother

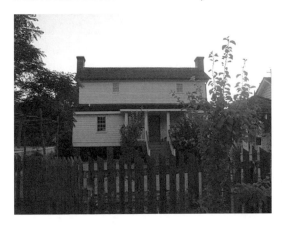

The Root House. *Rhetta Akamatsu.*

and their four children. All of the children shared one room with their parents. The upstairs bedroom on the right is the room that they shared and appears to be the center of any paranormal activity in the house. It contains two full-sized beds, a cradle and a jumble of other furniture and children's toys. Here is where the family spent the most time together and where, in all probability, one son died, as we know that the Roots did lose a son. It is no wonder, then, that some people claim to have seen Mrs. Root in this room in recent years, although the curator and the present volunteer staff say they have not seen any evidence of her or of any other spirit. At least one former docent had a different story to tell, as we shall see.

Mr. Root was a very successful businessman for many years and was influential in the development of the town. He was one of the founders of St. James Episcopal Church, established in 1842, and was Sunday school superintendent for fifty years. His drugstore received the first shipment of goods on the brand-new railroad. But he faced tragedy while living in this house, as well, including the death of his son and the eventual failure of his business. After his business failed, he was employed by St. James Episcopal and worked there until his death. He also served as county coroner for two terms, beginning in 1883. He died in 1891 and is buried at Marietta City Cemetery.

The bed that Mr. Root and his wife shared is the object of another legend concerning Root House, which, though dismissed by the curator, was told in the past by at least one junior docent and has gained considerable popularity in the town. The bed is a type commonly found in homes of that time, known as a "rope bed." These beds use a network of ropes to support a mattress, also known as a "tick," which was filled with cornhusks or feathers. The ropes were attached to a handle that you turned to tighten the network and keep the mattress from sagging. According to the docent's story, when the docents finished the last tours and were preparing to leave, they would make sure that the ropes were tight and the mattress firm. When they would arrive to start the next morning, the mattress would have an indentation in it, which looked very much like the imprint of a body, as though someone had slept on it during the night. They would have to rewind the handle to tighten the mattress back up.

No paranormal investigation team has ever been invited to attempt to prove or disprove any of these legends, and the present curator

The Root House bedroom, with the rope bed that has inspired a legend. *Rhetta Akamatsu.*

disavows any knowledge of or belief in any paranormal activity in the house. Despite this, townspeople continue to report seeing Mrs. Root in the upstairs window, looking down at her city.

The Root House is a warm and friendly house, and no one, to my knowledge, has ever felt anything sad, frightening or unfriendly in the house. If there is any truth to these legends, perhaps Mrs. Root or some other family member is simply visiting, to make sure that the house where they lived and raised their family is still being taken care of and to revisit old memories.

The Clay House

In the late 1800s, Alexander Stephens Clay, a senator from Georgia, built a two-story house with a wraparound porch in the Queen Anne style on the location of what had been the Slaughter cottage, home

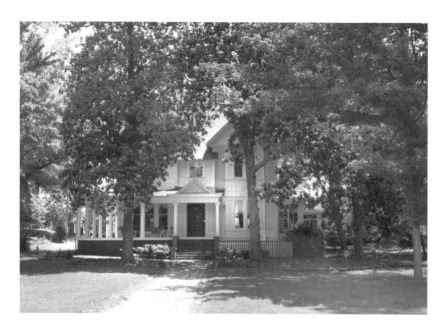

Above: The Alexander Clay House, where Mrs. Clay is seen. *Rhetta Akamatsu.*

Left: The statue of Alexander Clay in Glover Park at Marietta Square. *Rhetta Akamatsu.*

of one of Marietta's earliest doctors, Dr. M.G. Slaughter. The house still stands on Atlanta Street in Marietta.

Alexander Stephens was a very important political mover and shaker in Marietta in the post–Civil War 1800s. He was born in Powder Springs, but he began a law practice in Marietta in 1877. In 1880 and 1881, he served as a city councilman, before serving as a member of the Georgia House of Representatives from 1884 to 1890, including two terms as speaker pro tempore in 1886–87 and 1889–90. In 1892–94, he moved up to the position of president of the Georgia Senate. Finally, in 1896, Stephens was elected to the U.S. Senate, where he served three terms, dying while in office in 1910. He is mainly remembered by citizens of Marietta today because of the statue of him that stands in Glover Park.

The Clay House is now in an area that is commercially zoned and is used for offices. According to *Marietta 1833–2000*, members of the Clay family and office employees claim that the house has a resident ghost. Though Clay was deeply involved in Marietta history, it seems to be Mrs. Clay who is still often seen looking down from an upstairs window. (It seems that upstairs windows are the favorite spot of many of Marietta's ghosts, which may take a lively interest in what goes on in the city they helped to develop and grow.)

A CONTEMPORARY MARIETTA GHOST STORY

The following story is not one that you will read in any other book. The young woman to whom the events occurred is my daughter. I was often in the house where the events took place and personally witnessed and can attest to the activity surrounding the house and the doll.

The Haunted Doll

The young woman to whom these events happened is named Rose, nicknamed Rosie. It all began when her stepfather and I bought her a doll from a Family Dollar store on her twelfth birthday.

Even though she was no longer playing with dolls at that point, she wanted one of the dolls at the store because it looked so much like her. She is a natural blonde, and this doll was blonde and blue eyed and really bore a remarkable resemblance to her. It was called a Rosie doll, and when you held both its hands, it sang "Ring Around the Rosie." The way it worked was that there were sensors in the hands and you had to either hold both hands or have someone hold your hand and the doll's hand so that it would work. You couldn't just hold one hand; it had to be a complete circuit. For the next seven and a half years, it was just a normal doll.

But then, when Rosie was eighteen, she moved out on her own for the first time, into a house in a section of Cobb County very near the Marietta/Smyrna line. She had a couple of roommates, but for the sake of their privacy, they will not be named in this story. It is important to note, however, that one of them was an artist who had an interest in the darker arts, and that interest may have helped encourage the activity that occurred.

From the beginning, the house had a lot of negative energy, which was noticeable even to people who are not usually sensitive to that sort of thing. Not long after Rosie and her roommates moved in, they were told that a young man had hanged himself in the closet of the back bedroom at some earlier time. Rose had no fear of ghosts or the paranormal, which is a good thing, since that was her bedroom.

Rosie was at that time apprenticed to a special effects artist in Atlanta, and soon the room was littered with fake heads, limbs and other body parts she was working on. Her involvement in this dark subject matter and her lifelong sensitivity to the paranormal may also have helped create an opportunity for what happened in the house.

Rose had brought her Rosie doll with her to the house, packed away in a box in her closet. At this time, the doll had never shown any signs of being anything other than a normal toy. Rosie had never played with it much, but she liked having it with her as a novelty.

Before long, however, Rose became involved with a young man whom she subsequently married, and when he moved into the house, all sorts of paranormal activity began to occur. It was the usual things that people tend to experience in classic hauntings: scratching on the wall, footsteps, unexplained noises and glimpses of fleeting shapes from the corner of the eyes. It made Rosie's boyfriend very nervous, but Rosie had experienced paranormal activity before, and I have always been interested in the subject, so she was not really alarmed; that is, until one evening when things took a more dramatic turn. It seems that the entity in the house found a toy to communicate through to make its presence known.

One night, when Rose and her soon-to-be husband were sleeping, they heard the doll under the bed, right below their pillows, singing. Rose knew that she had not put the doll under the bed; she had never even unpacked the doll. It had been in her closet in a box ever since she moved into the house. The couple grabbed the doll, threw it in

the closet and rushed to my house in the middle of the night, too spooked to sleep in that room.

When they got back home the next morning, they tried to throw the doll away, but it showed up right back in the room again later that day. It is very possible that someone saw it in the trash and returned it, but rather than take a chance that something even scarier might occur, they wrapped the doll in a bunch of clothes so they couldn't hear it and put it in the closet.

The artist roommate was very intrigued by the doll, and at first Rosie said that he could have it, but I was very adamantly opposed to that idea, mainly because of his interest in the dark arts. I did not want him experimenting with the doll and possibly stirring up things that should not have been stirred up. Also, I did not feel that the doll itself was anything other than a tool for the spirit in the house. So Rose kept the doll, but she took the batteries out of it and put it in a drawer. Sure enough, it stopped singing, but it didn't stop talking.

It continued to say "Rosie...R...R...R...Rosie" in this very creepy, run-down sort of voice from time to time. For days, they would hear nothing, and then it would start up again, saying just the word Rosie over and over. I witnessed this phenomenon more than once.

Again, they tried to throw the doll away, but it always reappeared in the house, so they kept shutting it up in a drawer. By this time, since the doll never appeared to move and never did anything threatening, Rose and her boyfriend had sort of gotten used to it and were no longer so afraid.

At this point, Rose and her husband-to-be moved to another house in Marietta and left the doll behind, "accidentally." Everything was fine, and then they found the doll in a box in the bedroom of the new house. She had stopped singing at that point, at least. They locked her in the closet in the spare bedroom under a bunch of boxes.

Now, Rose has decided there is no point in getting rid of the doll. For a long time she kept putting it in boxes that she was never planning to look in, but it kept showing up in boxes of her clothes or shoes whenever she tried to find something. Right now it's in a storage facility, we think, but Rose says she expects it to turn up any time and would not be surprised if it is in a box in her house right now, waiting to be found. She says that the doll is not really a problem now because it doesn't sing anymore; it just seems as though it wants to be near her.

I do not know if anyone is living in that house now, but it would be interesting to know if there is activity there or if the entity accompanied the doll and has either moved on or is still within the doll. I have suggested to it in the past that it is free to move on now, but I do not want to know badly enough to try to find the doll at this point. Rose and I are both content to allow the doll to remain wherever it currently is.

CONCLUSION

And so we have seen that Marietta is full of history and also full of spirits, both residual and seemingly intelligent. From Civil War soldiers and Native American spirits to more recent spirits who died of natural and unnatural causes, they seem to appear around Marietta and the neighboring area with surprising regularity. None of them have ever been known to do any harm to anyone, other than a minor scratch or two at the Devil's Turnaround or a good scare here and there. Whether you encounter one of these ghosts, or whether you even believe that they exist, they have a lot to teach us about the history, not only of Marietta but also of the South in general and humanity as a whole.

Marietta is a wonderful place to live and a great place to visit. We have great schools, historical buildings, lots of community activities and festivals, plenty of antique shops and good restaurants and the lure of being close to Atlanta but not in it. For many of us, the presence of the shades of the past is just an extra bonus, and as long as the spirits are not unhappy to be here, we are happy to coexist alongside them. Should you decide to try to experience some of these phenomena for yourself, or if you just want to learn more, I have included a section of resources at the end of this book. If you visit any of the cemeteries or other locations on your own, please make sure that you have permission. Trespassing is not only against the law, but it is also rude and disrespectful. And please be careful. Remember,

Conclusion

the living are far more frightening than the dead, and falling in a hole in the dark and breaking your leg is a much more likely outcome than any ghost encounter—and much more painful.

If you are experiencing a haunting, in the Marietta area or otherwise, and you either need help to feel comfortable in your home, feel threatened or just want to verify that what you believe is happening is really happening without being told you are crazy or over imaginative, please contact a reputable paranormal investigation group and have it come in and do an investigation. There are a number of groups in the area, including Ghost Hounds and Georgia Ghost Hunters. They will be happy to help you, free of charge.

I have listed many of these paranormal investigation groups around the country in my book *Ghost to Coast*, at the Ghost to Coast website, www.ghosttocoast.us, and in the Paranormal Directory, paranormal.boomja.com.

APPENDIX
VISIT SOME OF THESE PLACES AND LEARN MORE ABOUT MARIETTA

Earl Smith Strand Theatre
117 North Park Square
Marietta, GA 30060
(770) 293-0080

Ghosts of Marietta Walking Tour
131 Church Street Northeast
Marietta, GA 30060-1601
(770) 881-8011
$15.00 for adults
$10.00 for children (twelve and under)

Holly Springs Cemetery/Emerson UU Church
2799 Holly Springs Road Northeast
Marietta, GA 30062-6631
(770) 578-1533

Johnnie MacCracken's Celtic Pub
15 Atlanta Street Southeast
Marietta, GA 30060
(678) 290-6641

Kennesaw House
1 Depot Street
Marietta, GA 30060-1910
10:00 a.m.–4:00 p.m., Monday–Saturday

Appendix

$5.00 for adults; $3.00 for students; $3.00 for seniors (fifty-five and over)
Free for members and children (six and under)

Kennesaw Mountain National Park
900 Kennesaw Mountain Drive Northwest
Kennesaw, GA 30152-4854
(770) 427-4686

Marietta City Cemetery and Confederate Cemetery
395 Powder Springs Street
Marietta, GA 30060

Marietta National Cemetery
500 Washington Ave
Marietta, GA 30060
(770) 428-5631

Marietta Welcome Center
4 Depot Street Northeast
Marietta, GA 30060-1910
(770) 429-1115

Petersen's Florist
268 Church Street Northeast
Marietta, GA 30060-1668
(770) 427-0271

Root House
145 Denmead Street
Marietta, GA 30060
(770) 426-4982
11:00 a.m.–4:00 p.m., Tuesday–Saturday
$4.00 for adults
$3.00 for seniors and groups (ten and up)

"Scary-etta" Tour
Historic Trolley Tours
131 Church Street Northeast
(770) 425-1006
$25.00 (plus tax) for adults
$12.00 (plus tax) for children (twelve and under)

St. James Episcopal Cemetery
161 Church Street
Marietta, GA 30060

BIBLIOGRAPHY

About North Georgia. "The Battle of Kennesaw Mountain." http://ngeorgia.com/history/kennesawmtn.html.
———. "The Battle of Kolb's Farm." http://ngeorgia.com/history/kolbsfarm.html.
Belanger, Jeff. *Ghosts of War: Restless Spirits of Soldiers, Spies, and Saboteurs*. N.p.: New Page Books, September 16, 2006.
Bonds, Russell S. *Stealing the General*. N.p.: Westholme Publishing, September 15, 2008.
Burns, Patrick. Ghost Hounds. Personal interview, March 2009.
City-Data.com. "Marietta: History." http://www.city-data.com/us-cities/The-South/Marietta-History.htm.
City of Marietta. "City Cemeteries." http://www.mariettaga.gov/departments/parks_rec/cemeteries.aspx.
———. "History of Marietta." http://www.mariettaga.gov/community.
Cobb Landmarks and Historical Society. "Cheney-Newcomer House." http://www.cobblandmarks.com/cheney-newcomer.html.
Cobb Preservation Society.
Conyngham, David P. *Sherman's March through the South. With Sketches and Incidents of the Campaign*. New York: Sheldon, 1865.
Ghostvillage.com. "Civil War Soldiers." http://www.ghostvillage.com.
Glover, James Bolan, Joe V. McTyre and Rebecca Nash Paden. *Marietta 1833–2000*. Charleston, SC: Arcadia Publishing, 2000.
Goodin, Joni. "Ghosts of Marietta Tour." http://ghostsofmarietta.com/.
Haunted Georgia. http://www.haunted-georgia.org.
Historic Ghost Watch. http://historicghost.com/.
History Channel. "Haunted Atlanta: The Kennesaw House." *Haunted History*, May 2009. http://www.history.com.

Bibliography

Holly Springs Cemetery Memorial Association. "Holly Springs Cemetery." http://hollyspringscemetery.org/history.php.
Hunter, Eddie. "Chicken Fat." http://ethunter1.blogspot.com/.
Interact Atlanta. "Ghost Hounds." http://revver.com/video/5930/ghost-hounds/.
"Johnnie MacCracken's." http://www.johnniemaccrackens.com/.
Kirby, Joe. "Marietta Statue Honors Woman Who Saved Confederate Cemetery." *Civil War News* (November 2004).
Kirby, Joe, and Damien A. Guarnieri. *Marietta.* Mount Pleasant, SC: Arcadia Publishing, 2007.
Knight, Carleigh Kate. "Local Haunts." *Marietta Daily Journal*, October 2007.
Mabry, Norris. *Cobb County Reflections*. Privately published, n.d.
Marietta City Cemetery and Confederate Cemetery. Official brochure, N.d.
Marietta Museum of History. "Marietta, GA." http://www.mariettahistory.org.
McGee, Benjamin F., and William Ray Jewell. *History of the 72d Indiana Volunteer Infantry of the Mounted Lightning Brigade*. Lafayette, IN: S. Vader & Co., 1882.
McTyre, Joe, and Rebecca Nash Paden. *Cobb County*. Charleston, SC: Arcadia Publishing, 2005.
National Park Service. "Kennesaw Mountain National Battlefield Park." http://www.nps.gov/kemo/.
New Georgia Encyclopedia. "The Battle of Kennesaw Mountain." http://www.georgiaencyclopedia.org/.
———. "Brumby Family." http://www.georgiaencyclopedia.org/nge/Article.jsp?id=h-2653.
Ridley, Bromfeld Lewis. *Battles and Sketches of the Army of Tennessee*. N.p.: Missouri Printing and Publishing Company, 1906.
Roadside Georgia. "Marietta." http://roadsidegeorgia.com/city/marietta.html.
———. "Peter Kolb's Farm." http://roadsidegeorgia.com/site/kolbsfarm.html.
———. "Root House." http://roadsidegeorgia.com/site/root_house.html.
Roberts, Andy, founder, Atlanta Ghost Hunters. Personal e-mail, April 2009.
Roberts, Nancy. *Georgia Ghosts*. N.p.: John F. Blair Publisher, 1997.
St. James Episcopal Church. "Our History." http://www.stjamesmarietta.com/.
Temple, Sarah Blackwell Gober. *The First Hundred Years: A Short History of Cobb County*. Athens, GA: Agee Publishers, 1989.
United States Department of Veterans' Affairs. "Marietta National Cemetery." http://www.cem.va.gov/cems/nchp/marietta.asp.
Watkins, Samuel R. Inge, and M. Thomas. *Company Aytch*. N.p.: Plume, 1999.
Waymarking.com. http://www.waymarking.com.

ABOUT THE AUTHOR

Rhetta Akamatsu is a certified paranormal investigator and a member of Ghost Hounds Paranormal Investigation Group in Atlanta, Georgia, and of the national paranormal network ParaNexus. She is a longtime resident of Marietta, Georgia, where she lives with her husband and two cats, not very far from her grown son and daughter, who also live in Marietta.

Rhetta has been interested in the paranormal from an early age, having grown up in a house that had both a phantom car and, in later years, other occasional paranormal activity. She also has a strong interest in history, psychology and parapsychology.

In addition to this book, Rhetta has written two self-published books about the paranormal, *Ghost to Coast*, a handbook of ghost tours, paranormal investigation groups and haunted hotels around the country, and *Ghost to Coast Tours and Haunted Places*, which expands on the ghost tours in *Ghost to Coast* and also tells the stories behind haunted places in each state. Rhetta has written a non-paranormal book, *T'ain't Nobody's Business if I Do*, about blues women. These books are all available on Amazon.com.

In addition to her books, Rhetta maintains the Ghost to Coast website, www.ghosttocoast.us, and the Paranormal Directory, paranormal.boomja.com, and is the associate editor of the bimonthly electronic journal, the *Journal of Anomalous Sciences*, worldnexuspublications.com, to which she often contributes as well. She writes prolifically on the Internet and blogs often.

Other books in the Haunted America series
from The History Press include:

Ghosts of Atlanta: Phantoms of the Phoenix City
Reese Christian
ISBN 978-1-59629-544-5
$19.99 • 128 pages • 6 x 9 • over 20 images

Elite psychic medium and cold case researcher Reese Christian writes of the tragic past and the haunted present of Greater Atlanta. From Peachtree Street in the heart of downtown to the plantations and battlefields surrounding the city, join her in discovering the twisted histories of some of Atlanta's most infamous landmarks and forgotten moments.

Roswell: History, Haunts and Legends
Dianna Avena
ISBN 978-1-59629-308-3
$19.99 • 128 pages • 6 x 9 • over 50 images

From the banks of the Chattahoochee to the streets of Roswell's historic district, chilling specters remind us of this charming southern town's shocking past. Dianna Avena blends Roswell's history with tales of the city's most famous haunts—from the slave quarters of Bulloch Hall to the cracked graves in Founder's Cemetery—to send chills down the spines of locals and visitors.

To purchase, please visit www.historypress.net

Visit us at
www.historypress.net